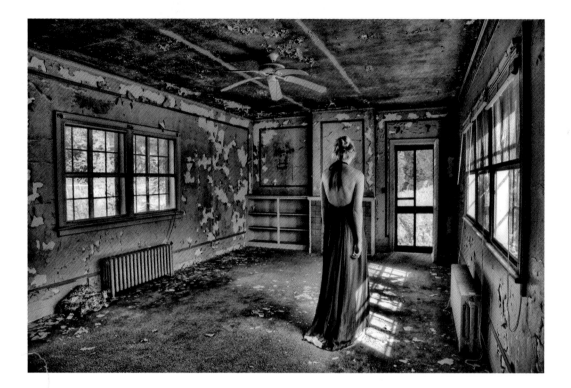

Rick Sammon's HDR Photography Secrets
for digital photographers

Rick Sammon

WILEY

Wiley Publishing, Inc.

Rick Sammon's HDR Photography Secrets for digital photographers

Published by
Wiley Publishing, Inc.
10475 Crosspoint Boulevard
Indianapolis, IN 46256
www.wiley.com

Copyright © 2010 by Wiley Publishing, Inc., Indianapolis, Indiana

Published simultaneously in Canada

ISBN: 978-0-470-61275-0
Manufactured in the United States of America

10 9 8 7 6 5 4 3 2 1

For general information on our other products and services or to obtain technical support, please contact our Customer Care Department within the U.S. at (800) 762-2974, outside the U.S. at (317) 572-3993 or fax (317) 572-4002.

Wiley also publishes its books in a variety of electronic formats. Some content that appears in print may not be available in electronic books.

Library of Congress Control Number: 2010922047

About the Author

Rick Sammon

Canon Explorer of Light Rick Sammon has published 36 books, and this, he feels, is his most creative effort.

His book *Flying Flowers* won the coveted Golden Light Award, and his book *Hide and See Under the Sea* won the Ben Franklin Award.

Digital Photography Secrets and *Studio and On-Location Lighting Secrets*, both published by Wiley, are among Rick's best-selling titles.

Rick has photographed in almost 100 countries, and he gives more than two-dozen photography workshops (including private workshops) and presentations throughout the world each year.

He co-founded the Digital Photography Experience (www.dpexperience.com), an online digital photography learning center. He co-hosts the bi-monthly Digital Photography Experience podcast, and he hosts five shows on kelbytraining.com.

© Judith Monteferrante

Rick has been nominated for the Photoshop Hall of Fame, and he is considered one of today's top digital-imaging experts. He is known for cutting through lots of Photoshop "speak," making it fun, easy and rewarding to work and play in the digital darkroom.

When asked about his photo specialty, Rick says, "My specialty is not specializing."

See www.ricksammon.com for more information.

Credits

Acquisitions Editor
Courtney Allen

Project Editor
Jenny Brown

Technical Editor
Alan Hess

Copy Editor
Jenny Brown

Editorial Manager
Robyn Siesky

Business Manager
Amy Knies

Senior Marketing Manager
Sandy Smith

**Vice President and
Executive Group Publisher**
Richard Swadley

Vice President and Publisher
Barry Pruett

Book Designer
Erik Powers

Media Development Project Manager
Laura Moss

**Media Development Assistant
Project Manager**
Jenny Swisher

Thank You

As you saw on the cover of this book, I get credit for taking the pictures on these pages and for writing the tips. And sure, I put a ton of work into this project; but the truth is, I had a lot of help—just like every author. No doubt, a book is a team effort.

So I thought I'd take this opportunity to thank the folks who helped put together this work as well as those who have helped me along the path to producing this book.

The always calm and patient Courtney Allen at Wiley was my main editor and project manager. She did a great job calming me down when things did not go as planned, and she was always patient when I was impatient. Thank you, Courtney, for all your help and understanding.

Barry Pruett, VP at Wiley, also gets a big "thank you." Thanks to my initial meeting with Barry, I have four books with Wiley and four how-to DVDs (on Canon cameras).

Behind the scenes, the following people helped bring this book to life. Thank you all for your eagle eyes and artistic flair!

Jenny Brown was my editor, making sure that what you read is actually what I meant to say. Like Courtney, she always had a smile on her face, even when she probably wanted to kill me!

Erik Powers did a wonderful job laying out this book, compiling the text and photos into pages that are easy on the eyes. Thanks, Erik, for making me look good!

Thanks, too, to Alan Hess for his technical editing.

Three Sammons get my heartfelt thanks: my wife, Susan; my son, Marco; and my Dad, Robert M. Sammon. For years, they have supported my efforts and helped with my photographs. Thank you for all your help and love. Especially, I want to thank Susan for toting my tripod all over the place and for being a great HDR assistant.

About my tripods: I use Induro tripods and Induro ball heads. My friends Joe Brady and Jeff Karp at the MAC Group fixed me up with these sturdy and lightweight tripods.

My good friend Capt. Jack gets a big thank you, too. He took a private workshop with me in San Miguel de Allende, Mexico, where several of the pictures in this book were taken.

Another friend who has helped me is Juan Pons, my co-host on the Digital Photography Experience podcast (www.dpexperience.com). Juan has kept me up-to-date on new technology, which one must do in the ever-changing world of digital photography.

My mystery friend on the cover of this book is Chandler Strange, a good friend and model with whom I have worked for years.

I'd also like to thank my workshop students, many of whom have shared their wonderful HDR pictures with me.

When it comes to photo industry friends who have helped me with the book, I have more than a few.

Rick Booth, Steve Inglima, Peter Tvarkunas, Chuck Westfall and Rudy Winston of Canon USA have

been ardent supporters of my work and my photography seminars. So have my friends at Canon Professional Service (CPS). My hat is off to these folks, big time!

Jeff Cable of Lexar hooked me up with memory cards and card readers, helping me capture images for this book ... and all my books.

Erik Yang at Topaz Adjust is one cool dude when it comes to keeping me up to date with great tips and techniques for using Topaz Adjust.

On the digital darkroom side, Adobe's Julieanne Kost; onOne Software's Mike Wong and Craig Keudell; and Tony Corbell and Ed Sanchez of Nik Software are always there to get me the latest and greatest info and software. And speaking of software, Scott Kelby of Photoshop fame gets a big thank you for just being who he is: a very sharing person.

And speaking of software and HDR, two photographers inspired me to get into HDR photography and to try new techniques: Trey Ratcliff and Ben Wilmore.

Thank you all. I could not have done it without you!

For My Family

Contents

About the Author

Thank You

Part III - Photomatix: The Most Popular HDR Program63

Part IV - Single File Pseudo HDR Images with Photomatix75

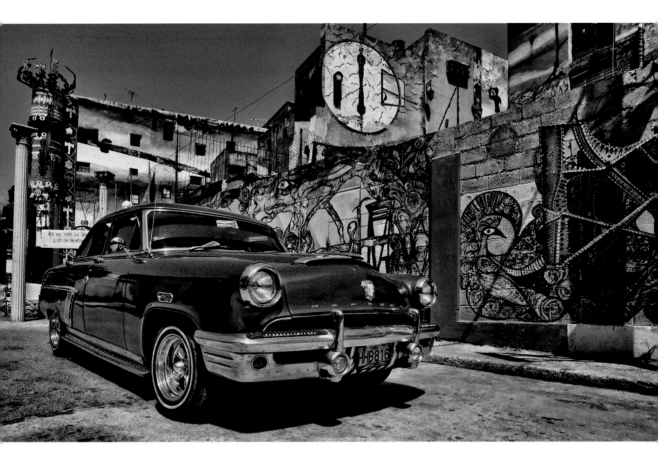

Preface

A Walk Before the Run: Basic Photography Tips

Yes! This book is about High Dynamic Range (HDR) photography. And you are going to love the extraordinary results of HDR techniques.

But keep in mind that photography is photography—no matter what you call your approach or delivery. That's why this book begins with tips that will not only help your HDR techniques; they will improve all of your photography.

So you will not find any HDR tech talk in this Preface. You'll find it in the other chapters; but for now, let's focus on the basics of photography.

To illustrate my tips, I use some of my favorite pictures of vintage cars (and one truck) that I shot during my travels. You'll learn how to create similar HDR images in this book, so stay with me here.

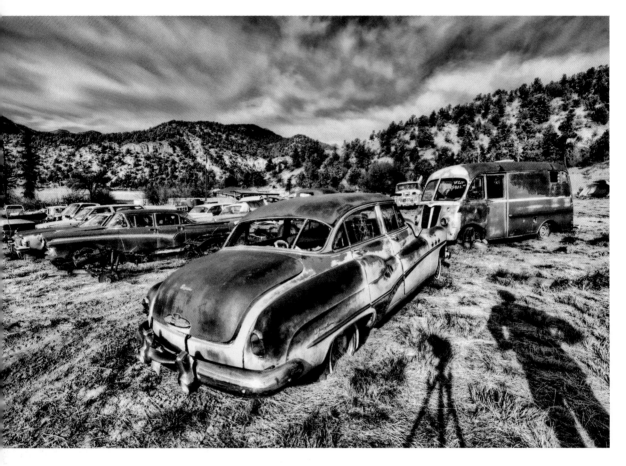

Make Photographs

Before you can approach HDR work, it's important to understand this very basic first tip: *Make* pictures; don't simply *take* pictures. There is a big difference between the two!

Making pictures is fun and creative. It's about adding your signature touch to the images you create. Conversely, *taking* pictures is more of a snap-and-go process. There's not much creative thought involved.

For example, I made this picture by including something in the scene that very few photographers would include in a picture: my own shadow. I also made the picture by following many of the tips that you'll find on the following pages.

After reading this book, you'll have a ton of ideas for making pictures—indoors and outdoors, in bright light and in low light, and in many other different types of settings. Use them in your own creative way and make photographs that mean something to you.

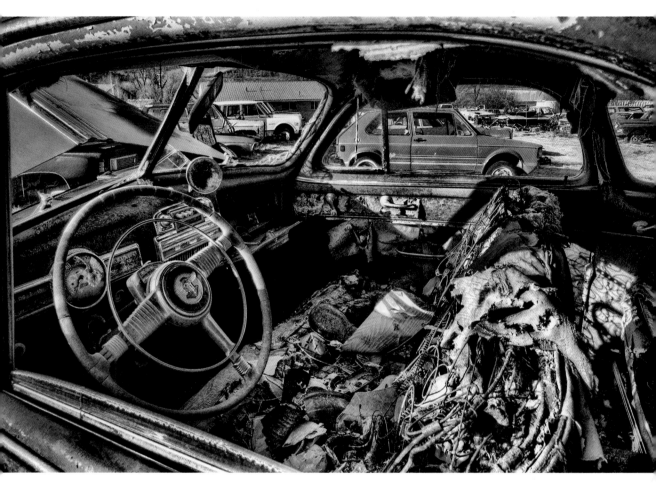

Tell a Story

As photographers, we are storytellers. One way to tell a story is to take a variety of pictures of the same scene or subject in the same location. Take wide-angle photographs and close-ups that show details.

When photographing, imagine that you are shooting a movie with many still frames that will eventually go together to, that's right, tell a story about your subject or location.

Consider the Background

When composing a picture, it is very important to carefully consider the background. Be aware of the impact it might have on your photograph. Distracting subjects or elements can ruin a photograph, as might objects that are too sharply focused or too out of focus … or even too bright or too dark.

While composing this photograph, I paid close attention to the background, framing the Coke truck so that the letters on it could be seen.

You'll see this same scene, photographed from the opposite angle, in a few pages. I included this scene twice in order to illustrate a point: Many of the tips in this section apply to most of the images in this book.

The Name of the Game is to Fill the Frame

Filling the frame with interesting subject matter is an effective method for creating engaging photographs. While making this image, I moved the orange piece of metal into the frame to fill the dead space.

The sky is mostly filled with distinguished clouds, so I included it in the frame. Had it been an overcast day with a solid mass of gray clouds, I would have cropped most of the sky out of the frame.

All that said, using open space in a photograph can be effective. It depends on the story you are trying to tell.

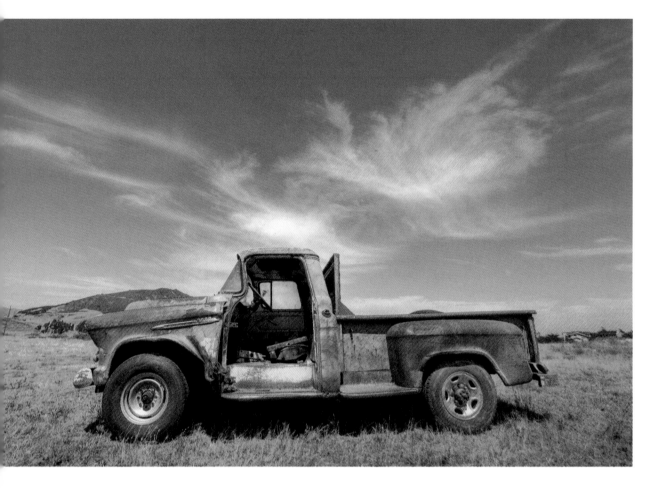

Check Your Camera Settings

Most professional photographers are constantly changing their camera settings to create the image they see in their mind's eye.

They change the aperture to control depth-of-field, the shutter speed to stop or blur action, the white balance to control color, ISO to control digital noise, and so on. I am one of those photographers.

Because I change my settings so often, I am constantly checking them before I shoot. That helps to avoid silly mistakes, which could result in missed photographs.

P.S. What might look like a dust spot in the sky is actually an airplane! I could have cloned it out, but leaving it in the image shows you the power of shooting RAW files with a high-end digital SLR camera.

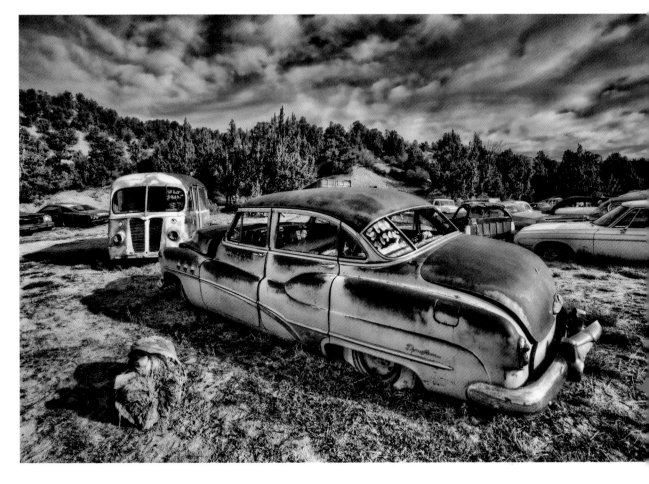

Choose Your Lens Wisely

Lenses are critical for telling a photographic story. Different lenses provide different views of the same scene, and different perspectives. Wide-angle lenses, when set at small apertures, let us capture wide scenes with good depth-of-field. For this photograph, I set my 17-40mm zoom lens at the 17mm focal length and set the aperture to f/16.

A scene photographed from the same position with a telephoto lens would have less depth-of-field, which might be desirable when photographing wildlife or a person. Generally speaking, I've found that a wide-angle lens is most conducive for HDR photography.

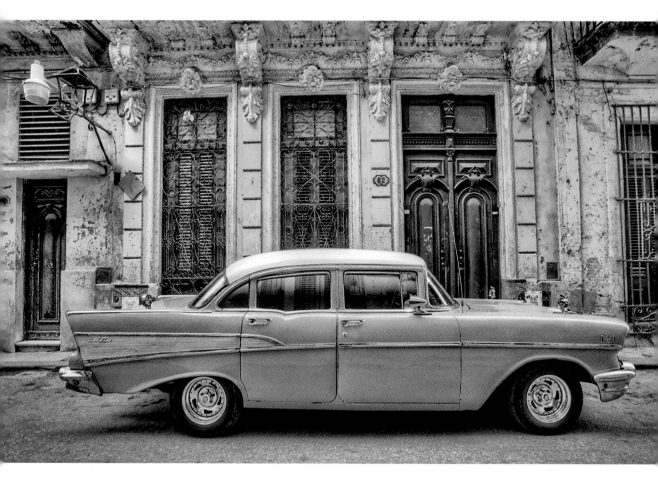

Interesting Subjects Make Interesting Photographs

Never underestimate the importance of an interesting subject. Seek out interesting subjects, and photograph them in an interesting setting. Then, take the time to make a picture.

This 1957 Chevy is an interesting subject. It became more interesting when I asked the owner to open the hood and the trunk. Another story for another time ...

Anyway, the setting is interesting, but it was not the original location of the car. I first spotted this Classic in the bright—extremely harsh and unflattering—sunlight. I asked the owner to move it into this position on a shady street, which reduced the contrast range and offered much more flattering light.

Once again, making pictures is fun and creative—and the result is much better than the passive, point-and-shoot alternative.

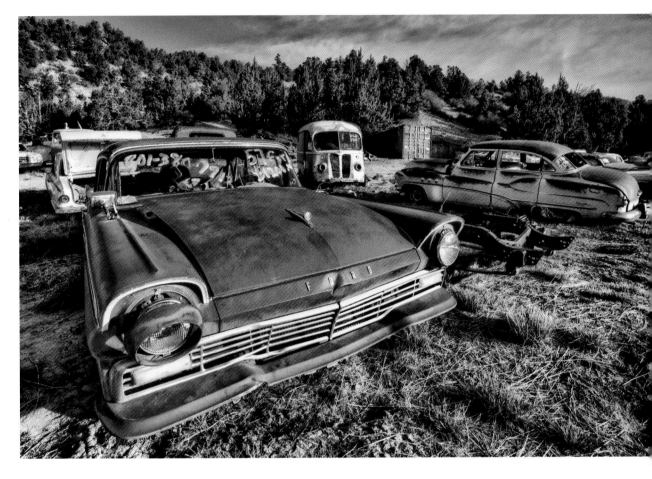

See the Light

I will talk about light more than a few times in this book. Because, when it comes down to it, every picture in this book has a common main element: light. No light, no picture.

Before snapping the shutter, be sure to take note of the characteristics of the light. See the direction of light, the contrast range in the scene, the quality of the light and the color of the light. Then, be sure to respond appropriately to what you see.

When it comes to HDR photography, a photographer has a tremendous amount of control over the light. However, we still need to see the various aspects of light so we'll know how to control it. Yes, you'll learn how to do that in this book.

The light in this picture is beautiful, coming from about one o'clock and slightly behind the subject. Because it was a sunny day, the light was strong, creating a nice contrast range in the scene. However, the angle of the sun also created strong shadows, which I opened up using HDR technology.

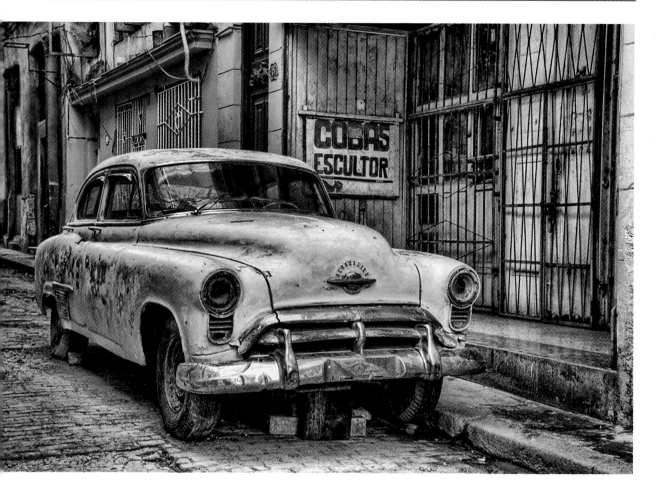

Create a Sense of Depth

While we see the world in three dimensions: height, width and depth, cameras only see two: height and width. Therefore, in order to create realistic images, we need to create a sense of depth. Do that by photographing a subject at an angle. That's what I did when photographing this old car in Old Havana, Cuba. When you look at the photograph, you can see down the street.

Shadows also help to create a sense of depth. This is why, as you will see, you don't always want to open up shadows when creating an HDR image. More on that later …

Move It

Here's a fun idea: Don't take all your pictures standing straight up. Instead, move your camera up and down. Tilt it down and to the left or right. Pitch it backward or forward. Just do things a little differently to create unique perspective for the viewers of your images.

I took this picture while kneeling on the ground to give the car a greater sense of power.

Take a Walk

When you encounter a subject that you'd like to photograph, shoot your take. Then, take a walk around the subject.

I know this tip sounds very simple, like some of the others in this chapter; but it's a good one. The more time you take to explore your subject from different angles, the better off you'll be at creating an interesting image with it. I think you'll find that the most engaging angle is not always a straight-on shot of the subject's front.

Compose Carefully

Composing your photographs is of utmost importance. Before you shoot, consider what you want in your frame—as well as what you don't want to capture. Run your eye a round the edges to look for distracting or complementary elements.

In this frame, I wanted to include both door handles. This was just a personal composition element, and I like it.

Okay, now let's move on to the magic of HDR photography! Ready?

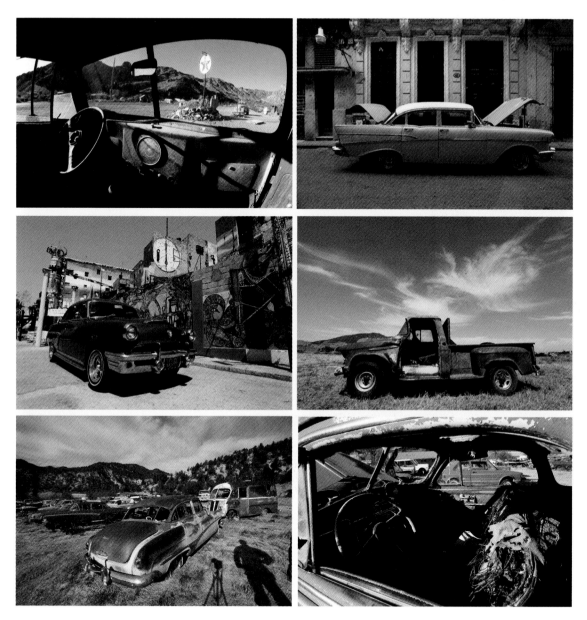

Before HDR

Okay, okay! I am sure some of you would like to see the original photographs for the HDR images in the Preface. Well, your wish is my command.

On this spread are the middle/average exposures—the RAW files—for the preceding images.

The scene on the bottom right on the opposite page had the most contrast; therefore it required the most amount of HDR work … stuff you'll learn about in this book.

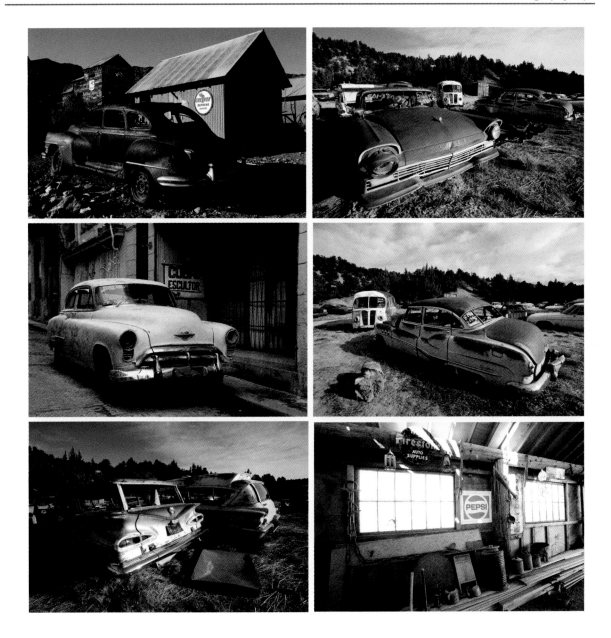

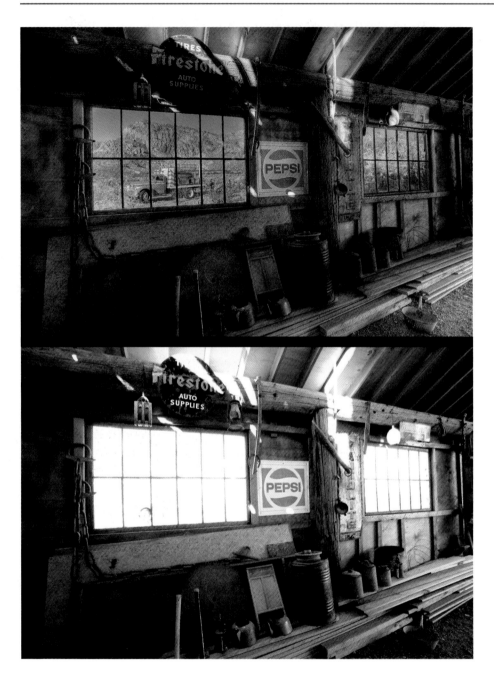

Extreme HDR

Because this scene had the greatest contrast and required the most amount of HDR work (seven exposures), I thought I'd show you the before/after pair of images. This is the kind of HDR magic that awaits you!

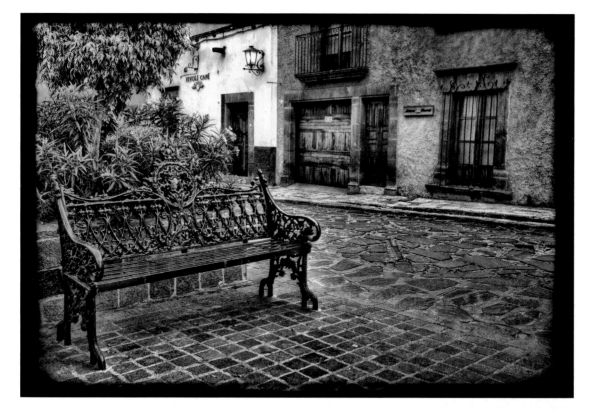

About This Book

Welcome! On the following pages you'll learn tons about HDR photography. For now, I just want to tell you a little bit about this book.

First, although you can skip around from chapter to chapter, I suggest you read the chapters in order. This will help you build on what you learn along the way. That will make the learning process more fluid.

Second, this is more than a book on HDR photography. It includes basic photography tips and techniques, including information on seeing the light (one of the first steps in making a picture), ideas on envisioning the end result, and suggestions on image editing.

Here is my favorite image in this book. It's an HDR photograph of a simple scene, and it was created from a set of pictures I took in San Miguel de Allende, Mexico. I dressed up the image with a digital frame.

In this book, you'll learn how to create artistic images like this one. You will also learn how to add digital frames to an image, which is a cool way to add impact to a picture.

About the Layout

This book contains more before-and-after sets of pictures than most how-to photography books, including my own. This technique is used to help you quickly and easily see the impact of HDR imaging techniques.

In most cases, the sets of pictures are presented together on the same page. Surely, that's not the best way to present an image; a one-picture-per-page layout would be much more aesthetic. But your learning process is more important to this project than the production of a gallery-style book of pretty pictures.

Here, on this spread, is an HDR image along with a screen grab of the images that were used to create it.

The subject is an old house in Westchester County, New York. Look at the HDR image. Notice that you can see into the shadow areas; yet the sky is not washed out. This is the coolest thing about HDR photography: an image can match the dynamic range of your eyes!

Here you see that the dynamic range in each image is nowhere close to the dynamic range of the HDR image. This is exactly why you need to combine images to achieve this effect. It's easy to do, as you'll learn while reading this book.

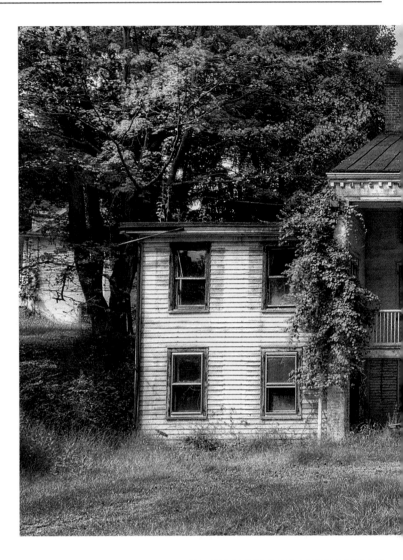

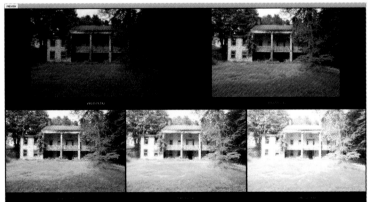

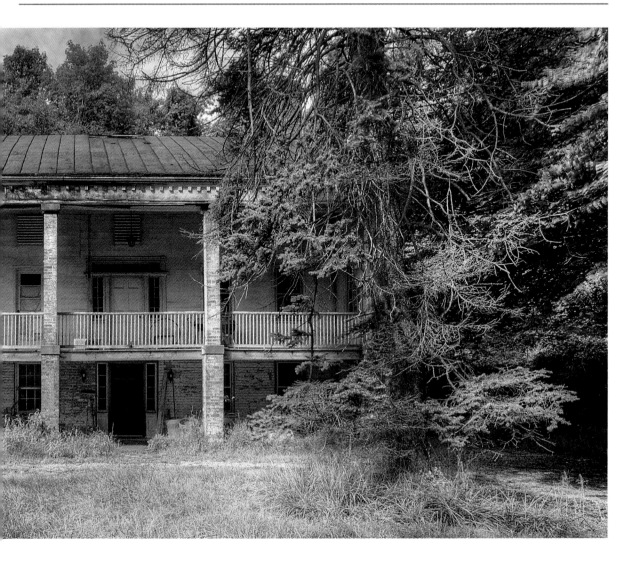

A New Way of Seeing

HDR photography will inspire you to develop a new way of seeing. Once you realize what can be done to enhance a captured scene's dynamic range, you'll begin to see the light differently when you are looking through your camera's viewfinder. You'll be able to better envision the end-result of your work.

On the opposite page, take a look at the image of Mt. Rainier. I envisioned this scene in my mind's eye while I shot the series of pictures needed to create that image (below).

In this example, three pictures were needed to capture the dynamic range of the scene, while five pictures were required for my old house image on the previous page. You'll learn about this stuff soon.

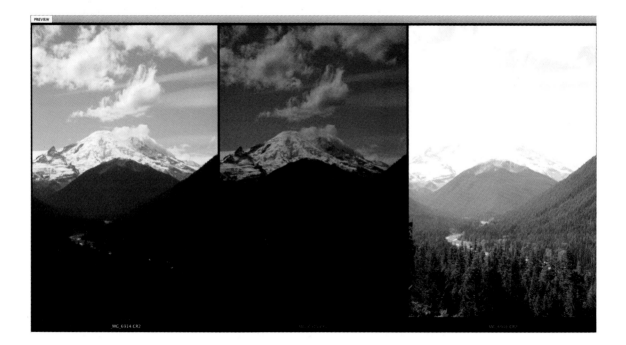

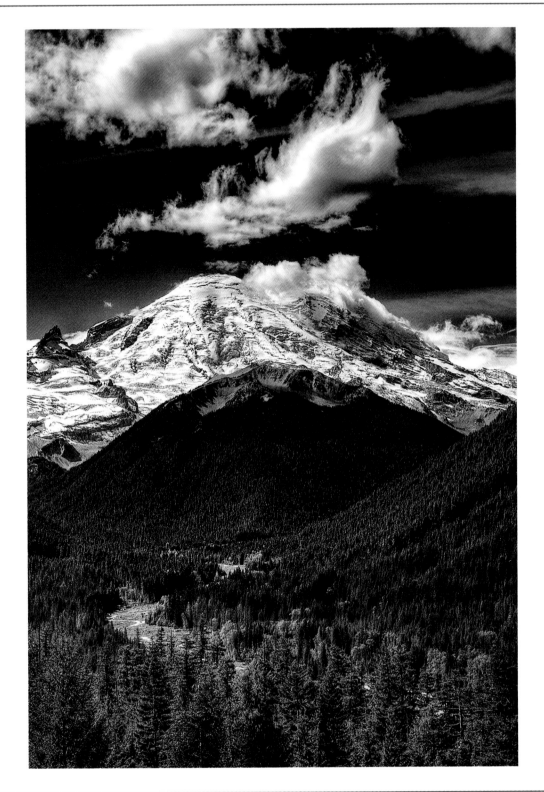

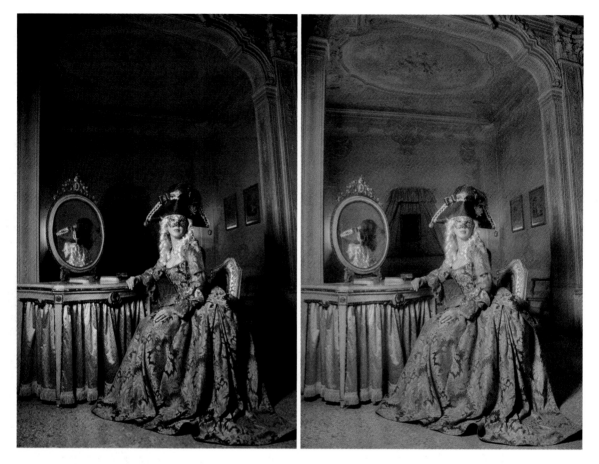

Don't Overdo It

One of the most important things to remember about HDR photography is that not every image or scene is made for HDR. In fact, some images look worse with this effect. My advice is not to overdo it; don't try to make every photograph an HDR image.

On this page, you see my original photograph, taken in Venice during *Carnevale,* on the left and the HDR image on the right. The HDR image shows an expanded dynamic range, but revealing the details in the shadows makes the image look flat.

On the right side of this spread is my Photoshop-enhanced image. It's cropped to add impact. Try cropping your pictures. You may be surprised to find pictures within a picture. Watch for other examples in this book of ways to enhance a photograph by cropping.

The drop shadow on my Photoshop-enhanced image was created by using the Drop Shadow Layer Style.

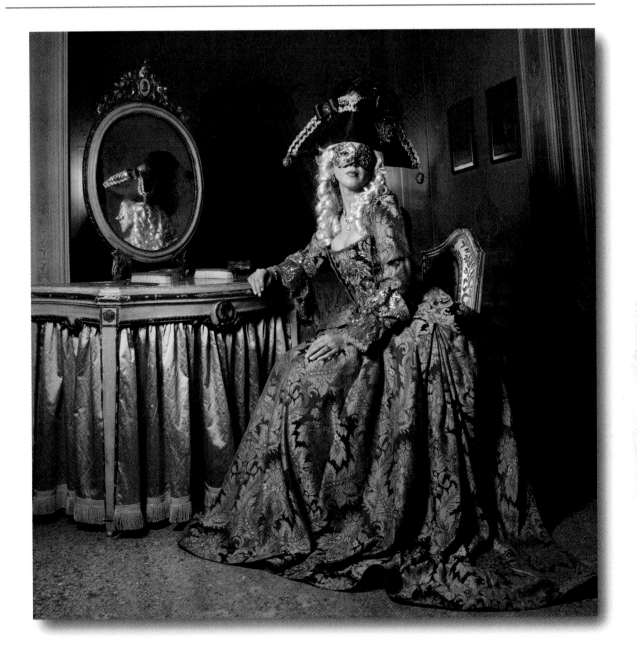

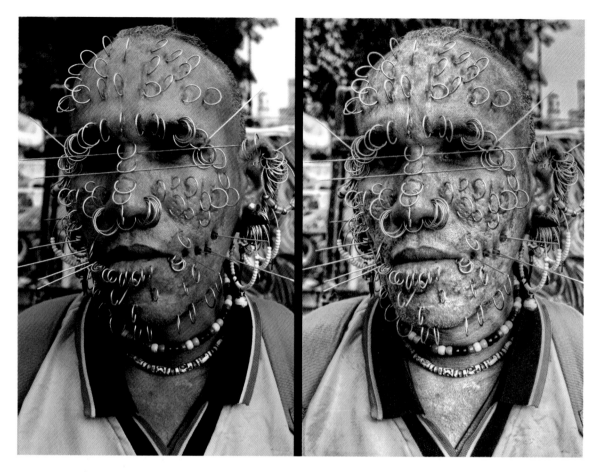

About the Pictures in the Book

Most of the pictures in this book were shot specifically for this project. This means that I took specific series of pictures to be processed with HDR software. And that required toting a tripod around and actually taking my time while shooting, which was an interesting experience for this "shoot and scoot" photographer.

However, I also created some HDR images from several old JPEG images, including the 2001 photograph above on the right. The picture on the opposite page is enhanced with one of the Grunge frames. It's available in PhotoFrame 4 Professional from onOnesoftware.com.

Read on to learn how to create HDR images … even from old JPEGs, and get a look at more digital frames. What fun!

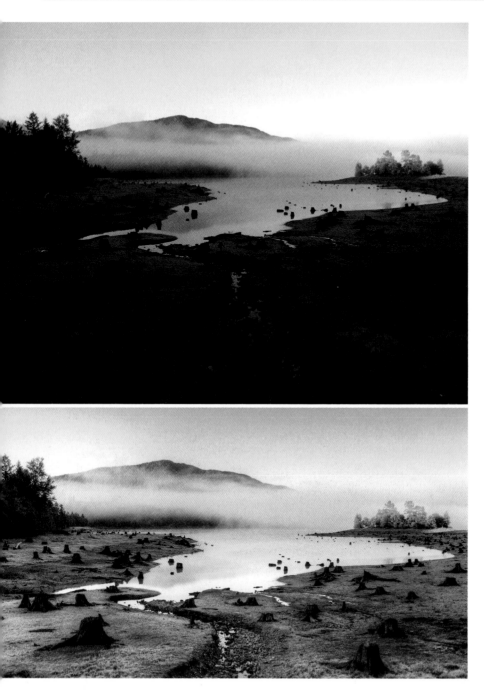

The Impact of Subject

You'll find all the information you need to make nice HDR images in this book. And that's a good thing. But never underestimate the importance of a good subject. It's something I'll say more than once.

Search out interesting subjects wherever you are, including your own neighborhood. It's also fun to travel to get inspired. I took the picture on this page in Washington State, and I shot the picture on the opposite page in St. Augustine, Florida.

Check out the before-and-after examples to see the benefits of HDR.

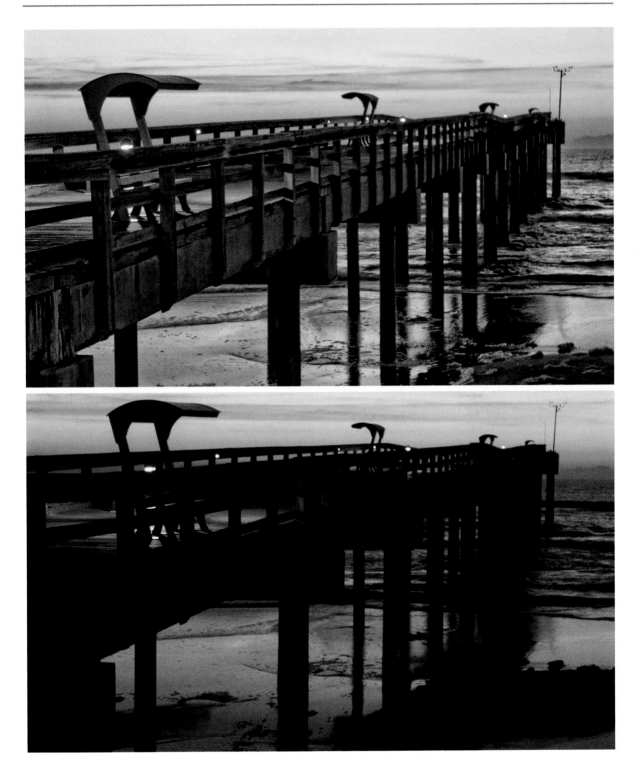

It's Photography

Perhaps the most important thing for you to take away from this book is this: Photography is photography, no matter what you do to it. A straight shot, an HDR image, an infrared, a black-and-white image—it's all photography.

HDR is a digital tool that helps you accomplish (to a greater degree) effects that wet darkroom photographers have used for years to expand the dynamic range of an image. Prior to digital technology, photographers used specific papers, filters, chemicals and processing times—combined with selective burning and dodging of photographs—to create HDR images.

This image, which I took on the beach in Los Osos, California, might be my favorite of 2009. To create it, I enhanced RAW files just a bit in Photoshop to bring out the shadow details in the background and on the beach.

You'll learn how to expand the dynamic range of a single RAW file later. For now I'll just say that RAW files are much better

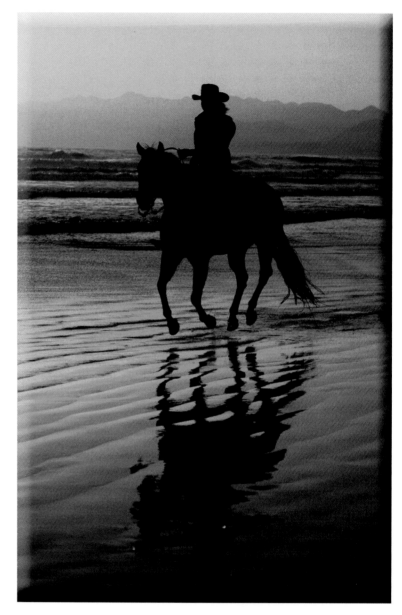

than JPEG files for HDR work. They contain much more information, and you'll need it! By now, you can see that I like adding digital frames to my pictures. This frame was created in Photoshop using the Beveled Edges Layer Style. More on that later, too.

Adventure Awaits

Take a look at this image in which I expanded the dynamic range in Photoshop. Again, no HDR program was used. Rather, I toned the highlights and the shadows for a dramatic silhouette.

With that, here we go. I hope you enjoy this book . . . and your adventures into the magical world of high dynamic range photography.

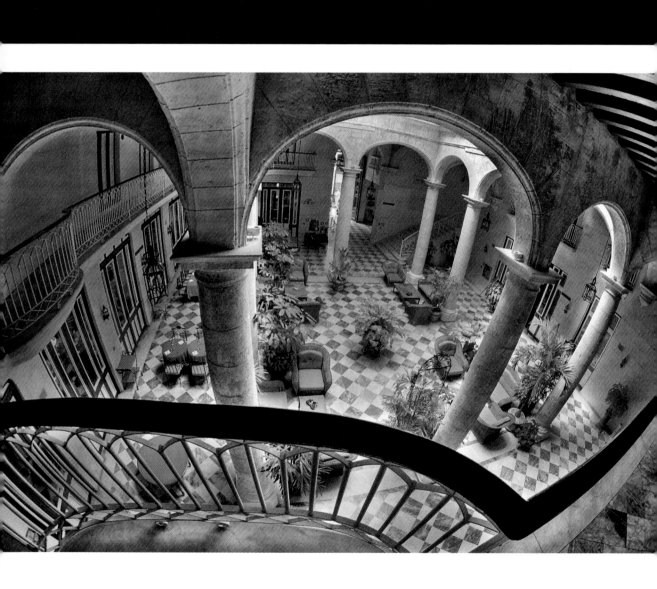

Introduction

Welcome to the magical and fun-filled world of HDR (high dynamic range) photography. I say *magical* because, from an emotional viewpoint, HDR images are filled with drama and wonder ... especially compared to many straight-out-of-the-camera photographs. What's more, HDR photography is a ton of fun.

From a technical standpoint, HDR images reveal details in high-contrast scenes—scenes with deep shadows and bright highlight areas—all in the same image. Previously, capturing a wide range of contrast in a single photograph was impossible without lots of digital darkroom work, complex lighting setups, the use of filters ... or a fantastic combination of all the above.

HDR images can also be filled with knockout texture.

Officially, HDR stands for *High Dynamic Range*, and we're applying this description to photography/ imaging. As a photographic technique, it's referred to as *HDR* because, by taking a set of pictures and processing them with an HDR software program, you can create an image with a much higher dynamic range than what is possible through the processing of a single image—no matter how skilled a person may be at using even the most sophisticated digital image-editing program.

The number of images required to be in a set that is intended for an HDR image can range from two to as many as nine separate photographs shot at different exposure (EV) settings.

That said, it is possible to pull a lot of information (shadows and highlights) out of a single RAW file if the contrast range is not too great.

My HDR program of choice is Photomatix from www.hdrsoft.com. After reading this book, you will be an expert on using Photomatix. You will also be adept at shooting HDR images and enhancing them in Adobe Camera RAW and Photoshop.

Get a 15% discount on Photomatix by using this code upon check out on the hdrsoft web site: ricksammon.

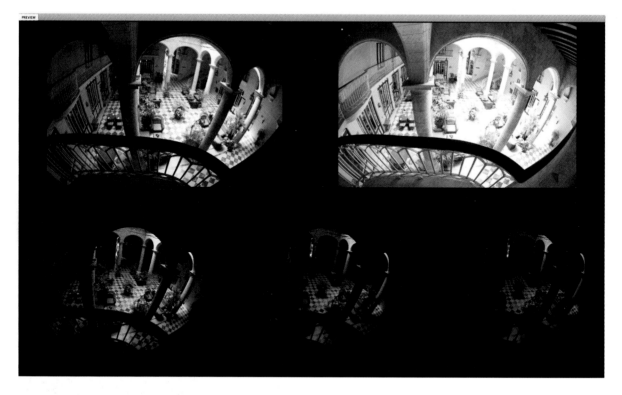

Bracketing is the Starting Point of HDR

I shot the opening image of this chapter with my Canon 5D Mark II and 15mm lens in the lobby of the Florida Hotel in Old Havana, Cuba. The image captures the entire dynamic range of the scene.

Here is a screen grab from Adobe Bridge that shows the single images that I shot at different exposures—over and under the recommended exposure (called bracketing)—to create that HDR image.

Later in this book, we'll talk about how many or how few pictures you may need for your HDR image. For now, just take a look at the opening shot and these images.

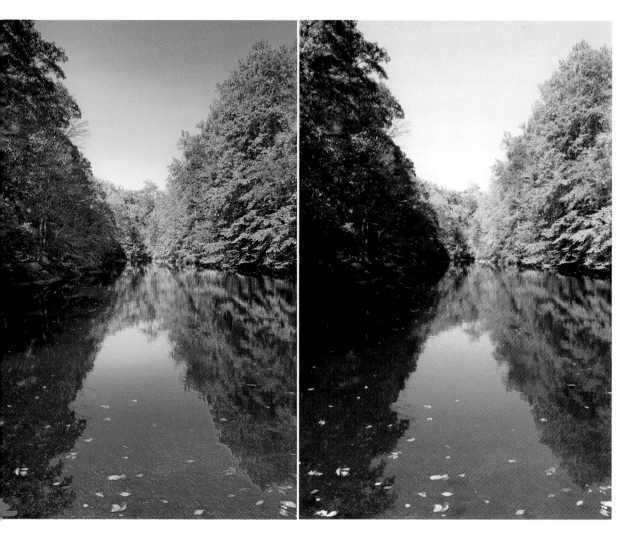

Creating an Effective and Impressive HDR Image

Some of the most effective and impressive HDR images make a viewer say or think (consciously or subconsciously), "Wow, I can't believe the photographer captured all the highlight and shadow areas in that scene. I can see all the details!" These viewers may have seen photographs of similar scenes and wonder why the HDR shot (not even knowing about HDR) looks so good.

Here is an HDR image, taken at Silver Lake in Croton-on-Hudson, New York, that illustrates that point (left). Also take a look at the scene when shot at an average exposure (right).

In the HDR image, you can see details everywhere. In the average exposure, some detail is lost in both the highlight and shadow areas.

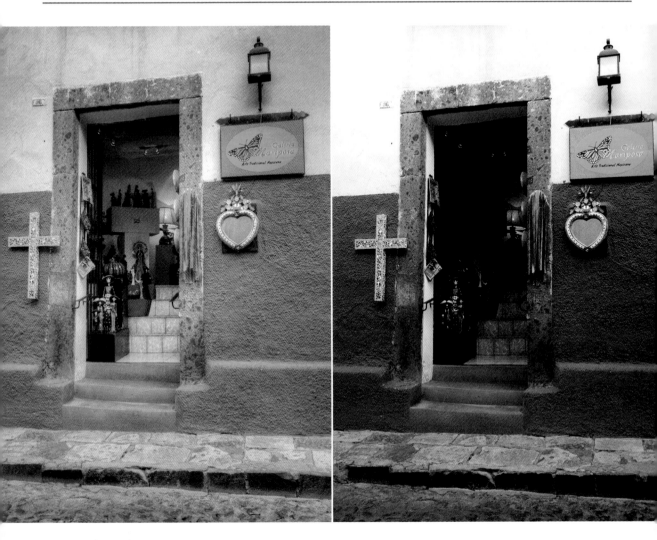

Seeing Into the Shadows

On the previous page, the HDR image revealed the detail (digital information) in the shadow areas of the scene. This is a primary benefit of HDR photography. It's so important, in fact, that I want to share another example with you—one that even more dramatically illustrates the effect.

In the HDR image of a doorway in San Miguel de Allende, Mexico, we can see inside the store ... and the detail on the wall outside is also more crisp. In the average exposure, some detail is lost on the upper part of the wall, due to overexposure. And most of what's inside is lost in the shadows.

Try HDR Even When You Don't Think You Need It

As you saw on the previous page, HDR is awesome when it comes to photographing scenes with extremely high contrast. Well, here's another idea: Try HDR even when you think you don't need it. You may be pleasantly surprised with the result.

I tried HDR on this shadow scene in San Miguel de Allende. I think the straight shot is cool, but the HDR shot is much cooler! Lots more detail in the entire scene.

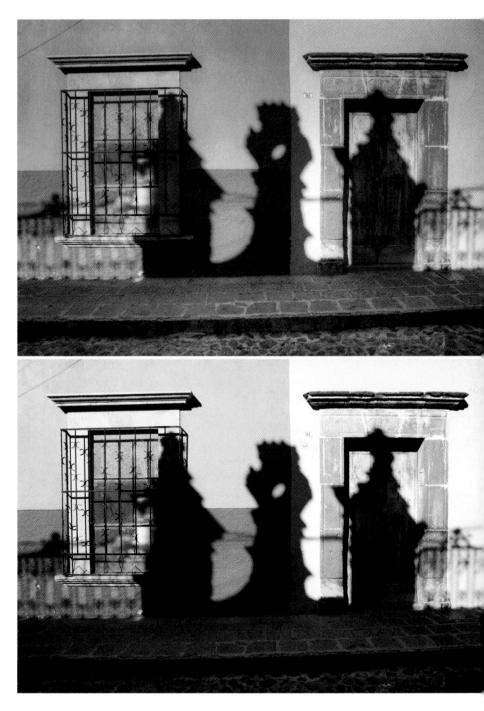

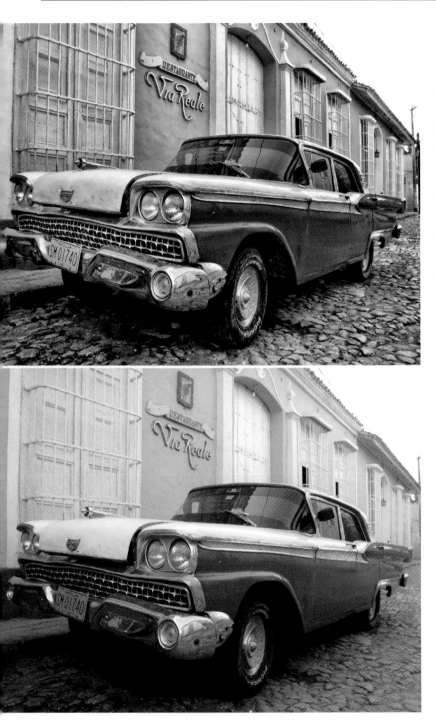

High Depth Range Images

Of course, I agree with the official definition of HDR. However, I'd like to add two additional options. Their credibility as definitions for HDR will become apparent as you continue to read.

One is *High Depth Range*, because … by increasing the dynamic range of an image, you can also add to its sense of depth.

To see what I mean, compare these two images of an old Ford that I photographed in Trinidad, Cuba. The straight shot is okay, but the HDR-like image has a greater sense of depth. In the HDR-like image, it appears that the bumper closest to the camera is even closer.

We'll get to *HDR-like* images later. For now, I'll just say that my Cuba car HDR-like image was created from a single image using Topaz Adjust's Spicify filter. Topaz Adjust (www.topazlabs.com) is not a true HDR plug-in or program. But as you can see, it does expand the dynamic range of an image.

I cover my second definition of HDR on the next page.

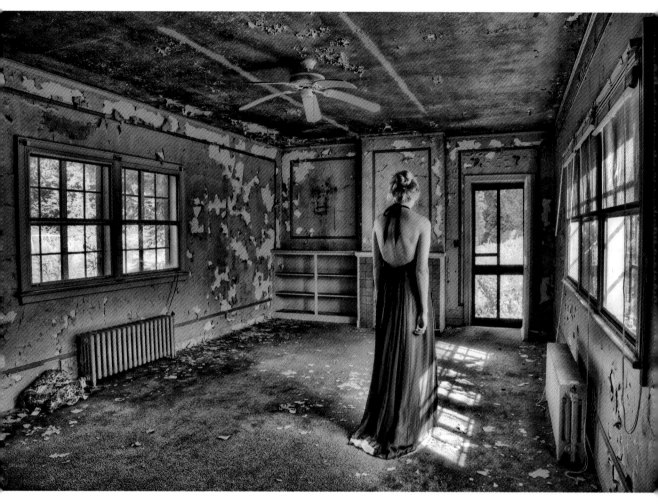

Highly Do-It-Yourself Rockin' Images

My other definition of HDR is *Highly Do-It-Yourself Rockin'* images, because … with HDR, you can create images that really rock!

This is one of my favorite HDR images. I photographed my friend Chandler Strange in an abandoned house not too far from my house in Croton-on-Hudson, New York. It's a true HDR image created in Photomatix, which was then processed with Topaz Adjust's Spicify effect. You'll see Chandler again later on.

To me, it's amazing that we can see all the detail both inside and outside the room.

As you'll see throughout this book, you can combine your true HDR images with Photoshop plug-ins and standard adjustments for rockin' effects.

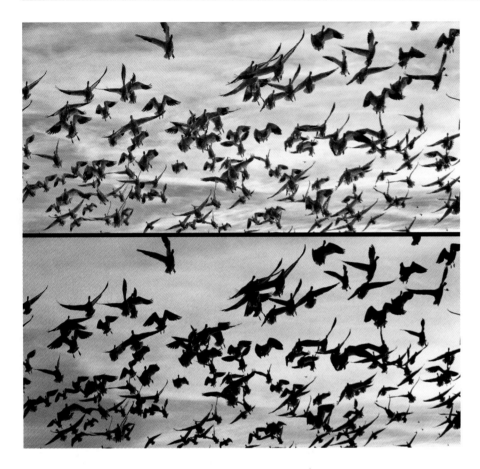

Pseudo HDR Images and HDR-like Images

Getting back to the topic of creating an HDR-like image from a single photograph ...

It is possible to create what is known as a pseudo HDR image or HDR-like image from a single photograph through the use of Photoshop enhancements and plug-ins, such as Topaz Adjust.

I created this pseudo-HDR image from a single photograph I took at Bosque del Apache, New Mexico, with Topaz Adjust's Spicify effect. This is only one of several pre-sets in the Topaz plug-in.

Notice in the pseudo HDR image: You can see details in the shadow areas and in the sky.

However, for true HDR imaging, you need a true HDR program, such as Photomatix, to process a set of images. Photomatix is a very powerful program that indeed works magic on sets of images.

Photomatix also lets you create pseudo HDR images from a single image. This will be covered later.

By the way, you can also use Photoshop to create the same effect as you see here, using standard adjustments. However, it would take you some time in the digital darkroom and you'd really have to know what each adjustment can and can't do.

Realistic or Artistic

When it comes to creating an HDR image, you basically have two choices. You can create a realistic image (one that represents a literal view of a scene) or an artistic image (in which reality is altered ... usually by increasing the saturations of the colors and details).

Here are three examples that illustrate (top to bottom): a creative HDR effect (Photomatix plus Topaz Adjust's Spicify filter), a realistic HDR (Photomatix only) effect, and a "correct" straight-out-of-the camera shot.

To me, the simple shot of a bench on a picturesque street in San Miguel de Allende, Mexico, has the look of a painting.

Keep in mind that before HDR technology was developed, the only kind of painting I could create was finger painting.

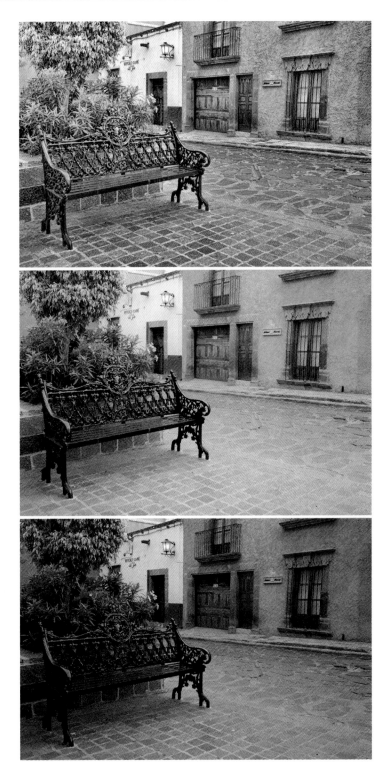

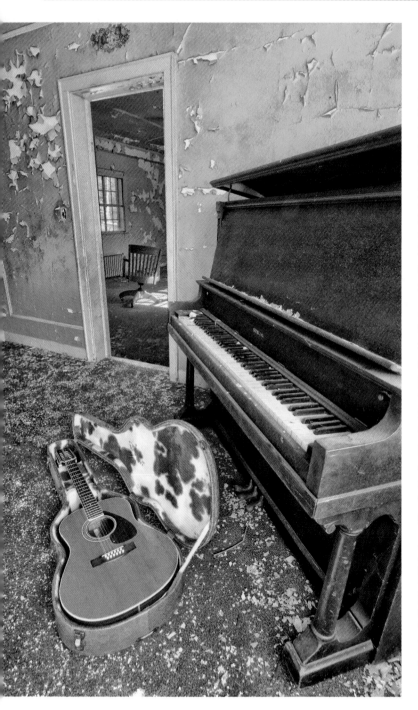

Envision the End Result

Here is something pretty amazing and very cool to consider. Once you become serious about exploring HDR photography, you'll get better at visualizing possible end-result images in your mind's eye. Your imaginary photographs will show all the details (in the shadows and highlights) that you see with your eyes … and more. It will look realistic or artistic, as you wish.

After the HDR photo session in the abandoned house with my friend Chandler, I kept thinking about (envisioning) other HDR photo opportunities. I knew I had to do something with the piano in the house. So, I took my guitar to the house, moved the piano, set my guitar on the floor, opened the case, and created an HDR image (Photomatix plus Topaz Adjust) that I not only envisioned, but also knew would rock.

Ansel Adams, one of the greatest photographers of all time, was big on visualization. As an HDR photographer, you will be big on seeing the end-result, too. The more you shoot and process HDR images, the clearer the pre-visualized image will be. Stick with it!

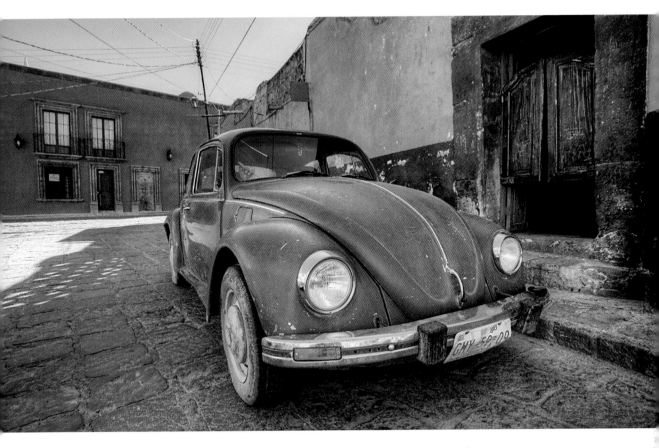

Composing in a New Way

Here is yet something else to consider in HDR photography: It'll inspire you to change your way of composing a picture. Why? Well, generally speaking, before HDR photography, if the contrast range in a scene was too great—and a photographer could not control (reduce) the contrast through the use of filters, flash/flashes or a digital darkroom program—then we had to crop out extreme areas of the picture ... either in-camera or in the digital darkroom. Think about that in terms of this photograph. The bright sky and the part of the street that's in the sunlight would have been overexposed had it not been for HDR photography.

Now, virtually no contrast range is too great. Just take enough exposures of the scene to cover the range and then process those images in Photomatix. After that, sometimes a few additional enhancements in Photoshop can take an image to yet another level.

This HDR image from San Miguel de Allende illustrates that point. Before HDR, I never would have shot this scene as wide as I did. That is, I would not have included the sky and bright area in the same scene with all that shade. HDR came to the rescue and allowed me to compose the scene in a way that is much more interesting to me.

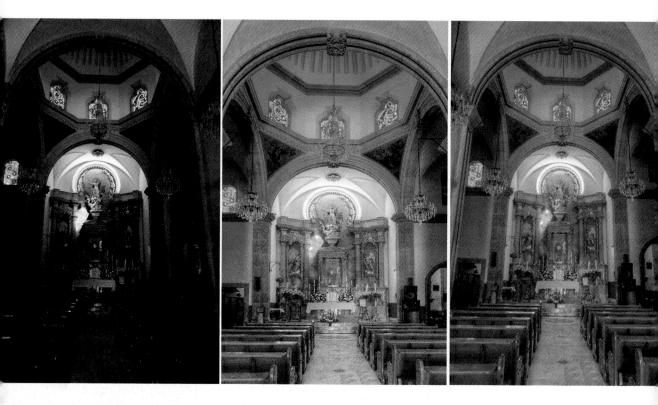

Life After HDR in Photoshop

I've found that many of the images I process in Photomatix either require some additional enhancements in Photoshop or can use a touch of Topaz Adjust. That's just me. And you'll find your own style, but don't settle for your processed Photomatix image. Experiment and play in Photoshop and with Topaz to explore the range of your image-making potential.

This set of images of the interior of a church near San Miguel de Allende demonstrates this point. The average exposure (left) was a dud—a photo failure! The Photomatix image (right) was cool. However, I had to do some work in Photoshop to create the image I saw in my mind's eye (middle). This work included correcting the distorted perspective with Photoshop's Transform/Perspective tool. Summing up, always try to visualize the end result … in your mind's eye and in the digital darkroom.

Rick Sammon
Croton-on-Hudson, NY
March 2010

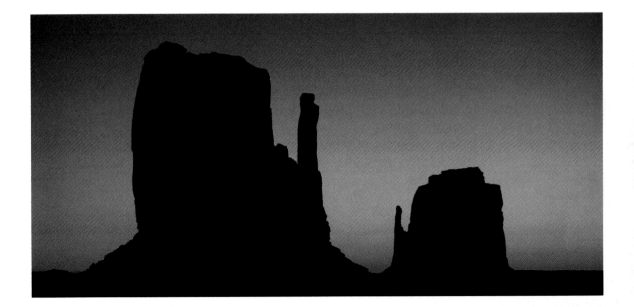

Part I

To HDR or Not to HDR ... That is the Question

I'm assuming you picked up a copy of this book because you want to learn about High Dynamic Range photography. Cool. You will learn a lot about HDR here. Most important, you'll learn how to use HDR imaging to create your own unique pictures—perhaps even works of art.

You'll also learn something else: There is a time and place for HDR. In other words, there are situations for which HDR is a dream. In other cases, you definitely don't want to use HDR, because it would spoil the mood or make the scene look bad.

Opening this chapter is one of my favorite non-HDR images. It's a sunrise photograph of the Two Mittens in Monument Valley, Utah. I could have used HDR, but opening up the shadows for a higher dynamic range image would have lessened the effect of the dramatic silhouette.

On the next page you'll see that using HDR on a similar scene was not the best idea. You will also see two examples of dramatic non-HDR pictures.

HDR is a very cool technique, but it's important to use it wisely. Knowing when to use it and when to leave an image alone will make you a better photographer. Just remember that a photograph is all about the light. Light illuminates a scene and light can be created in the digital darkroom. Light makes all the difference in the world.

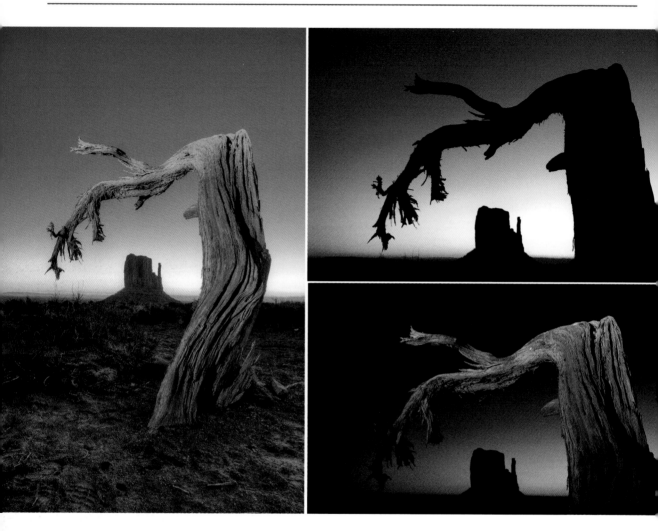

No Substitute for Good Light

Here are three pictures that illustrate HDR vs. non-HDR photography. The image on the left (Photomatix) is an HDR shot, created from several images. Sure, the dynamic range of the photograph is greater than the two images on the right, but the image on the left has no drama and looks flat compared to the other two pictures.

When a dramatic silhouette is your goal, HDR is a no-no.

By the way, I increased the dynamic range of the photograph on the bottom right by "painting" the tree with light from the headlights on our guide's Jeep.

Here is another thought when considering HDR or non-HDR photography: There is no substitute for good light. Make sure your scene is lit appropriately for the photograph you hope to create.

RAW Files are Packed with Data

RAW files contain a ton of data from which you can expand the dynamic range of a single image. You'll learn how to do that later in this book. For now, keep in mind that you can expand the dynamic range of RAW files only a few f/stops. That's compared to many f/stops when you take a series of pictures for processing in Photomatix.

We're back in Monument Valley here. I processed the top image in Adobe Camera RAW. My work reveals details in the shadow areas of the foreground without blowing out the highlights in the background. The bottom image is the unprocessed RAW file. It shows the big difference in brightness level between the shadow and highlight areas. Here, Adobe Camera RAW could handle that difference.

When you want detail in both the shadow and highlight areas of a scene, you'll need to think HDR … Expand the dynamic range with skillful processing of a RAW file or use Photomatix to process a set of images.

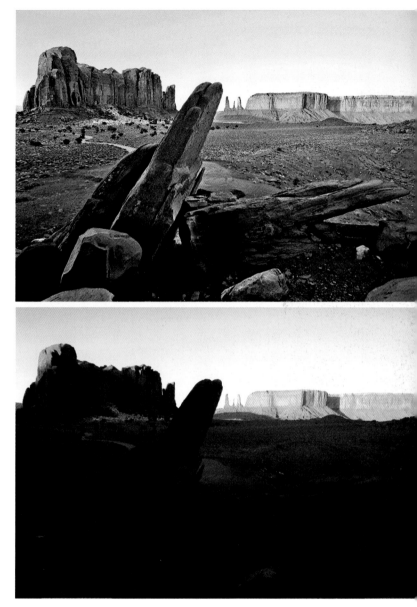

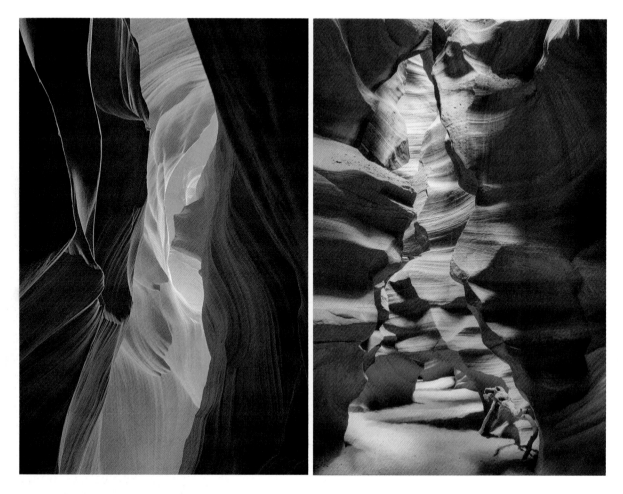

When HDR Rules

I created the image on the left from several images that I took in Upper Antelope Canyon in Utah. What a magical place to photograph. However, getting an even exposure in this cool location is not easy, due to the wide contrast range in the scene.

When the contrast range is very wide in a scene is when HDR rules. However, just because you can almost completely open up the shadow areas of scene does not necessarily mean you want to.

For this image, I wanted to include some of the shadow areas in the scene, because shadows can add a sense of drama.

Check out the files on the following page. These are the files I used to create this Photomatix image.

I took the photo on the right in Lower Antelope Canyon. The contrast range was not as great as in my Upper Antelope Canyon image, so processing the image in Adobe Camera RAW did the trick of bringing out the shadow details and toning down the highlights.

More Exposures Mean More Data

Here are the four exposures I took to create the HDR image on the left on the preceding page. The top right shot is the average exposure of the scene. The highlights are blown out and the shadows are too dark.

For my HDR image, as I mentioned, I wanted to maintain some of the shadows. Had I wanted more detail in the shadow areas, I would have taken additional shots, overexposing them to the point where I could see the details on my camera's LCD monitor.

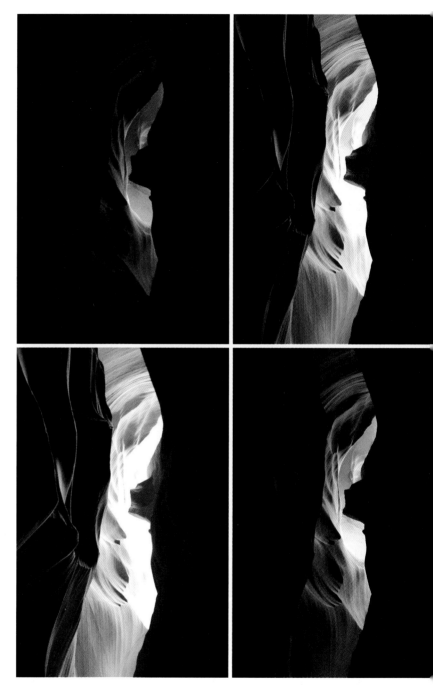

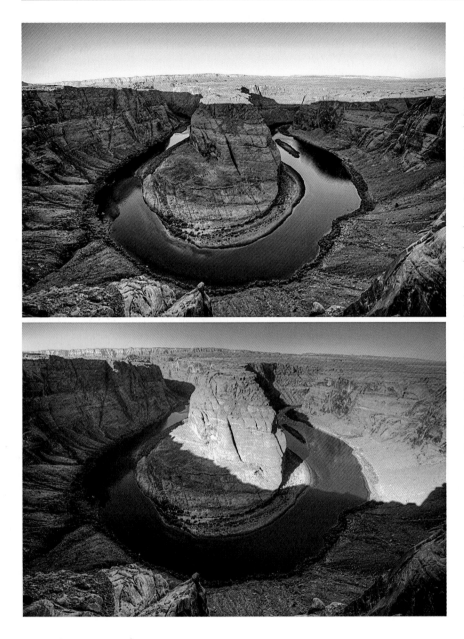

HDR is Not a Magic Fix

Here are two HDR images from a 2009 trip to Horseshoe Bend, which is near Page, Arizona— about a 10-minute drive from the Slot Canyons. In both images, HDR was used to avoid blocked up shadows and overexposed highlights caused by the strong shadow from the sun.

The pictures are okay, but personally I don't like the shadow in the scene. You'll find the remedy for this on the next page.

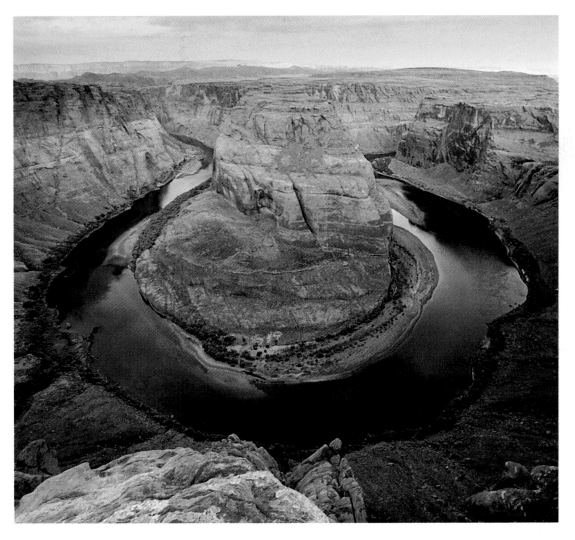

The Right Light for the Situation

Here is my favorite photograph of Horseshoe Bend. It is not an HDR image. It's a straight shot, actually taken in 2002, before HDR was available.

This image is a success because the contrast range is much less than in the images on the opposite page. In other words, there were no strong shadow areas and no bright highlight areas. That fortunate circumstance was created by an overcast sky.

For a scene like this, there is really no need to shoot HDR. You can expand the dynamic range, if you want to, in Adobe Camera RAW.

The message here is this: Sometimes you need to wait for the right light to get the photograph you envision … or be lucky and get the right light.

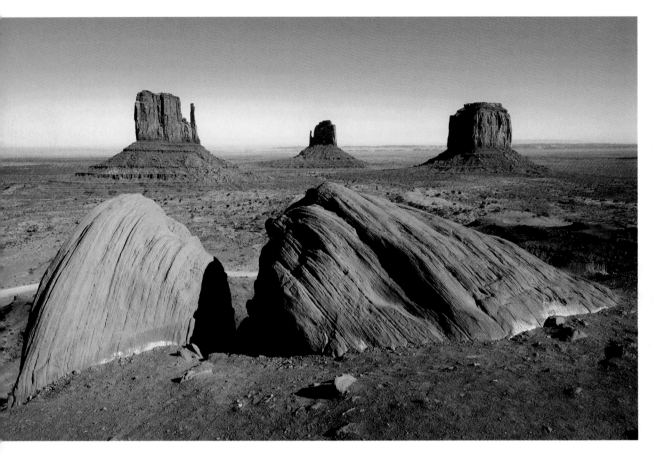

Strong Light Might Be the Right Light

Here is an example of when strong, direct sunlight can be the right kind of light for the image you want to create—and HDR is not required. The shadows in this case, created by late afternoon light, add definition to the scene. Remember: Light illuminates; shadows define.

It can be tempting to use HDR to open up shadows in a scene. And sometimes that's beneficial. Other times it causes a shot to fall flat.

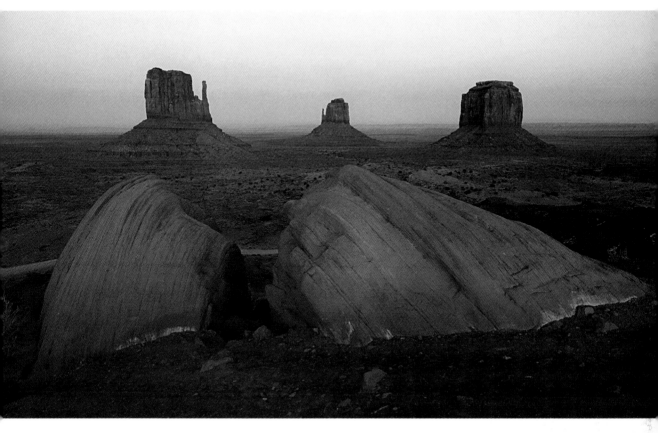

Soft Light is Sometimes Right, Too

Here's another non-HDR image. I took this photograph after sunset of the same scene that's pictured on the previous page. I love the soft quality of light in this picture.

Due to the low contrast range in the scene, HDR would not have done much. It may have opened up the darker areas of the picture a little, but that is easily accomplished in Photoshop. (Note: I actually did try an HDR version of this image, and it turned out pretty nice; but I prefer this version.)

The idea is to keep HDR in mind without trying to make each and every one of your photographs an HDR image. I recommend using HDR only when you need it or want to create a special effect.

Taking all of that into consideration, check out the opening image of the Photomatix Meets Topaz Adust chapter (Part VII). I created the artistic effect by combining Photomatix and Topaz Adjust … and then added a digital frame for a digitally created artistic image.

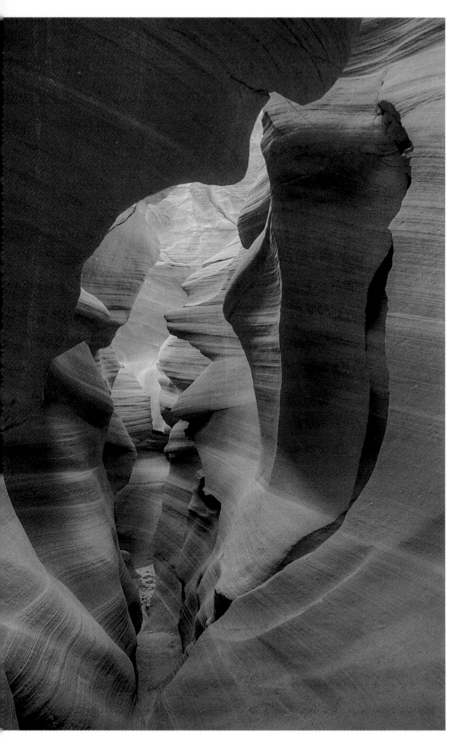

Always Be Prepared for HDR Photography

Because we often find ourselves in high-contrast situations, always be prepared for HDR photography … even if the intention is not to create HDR images.

Being prepared includes toting a tripod and having enough memory cards for all your image sets. Remember that HDR photography takes a lot of memory, because you need to shoot several exposures of a scene to create one image.

For this HDR image of Lower Antelope Canyon, I took five different exposures and then "crunched" them in Photomatix.

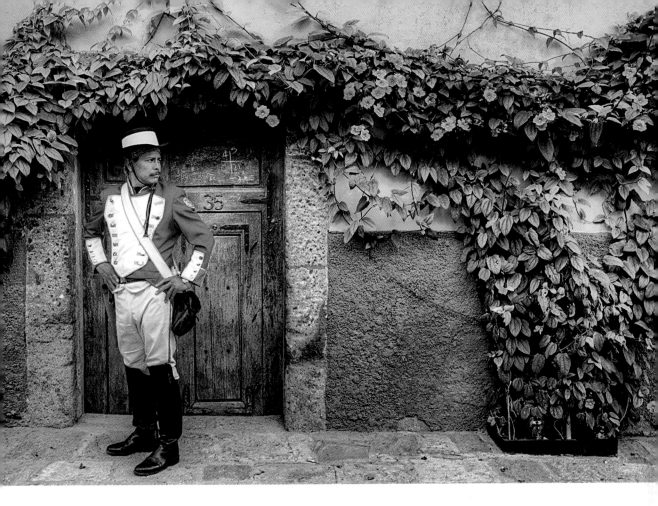

Part II

Must Know Info

This is a must-read chapter. It contains info that you must know for creating knockout HDR images. 'Nuf said.

You'll see this San Miguel de Allende, Mexico, police officer later in this chapter.

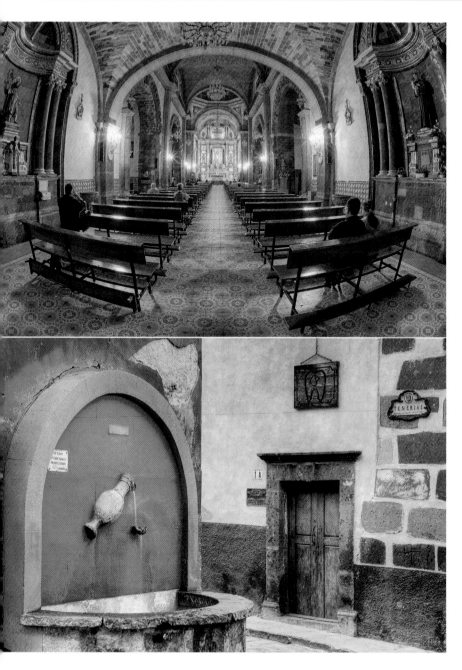

See the Light & Determine Bracketing

The first step in creating an HDR image (or any photographic image for that matter) is *seeing the light*. The most important part of this for HDR photography is seeing the contrast range in the scene. The contrast range is the difference between the shadow and highlight areas.

Seeing the color of the light as well as its direction and quality is also important, because these factors affect how we perceive a photograph. For now though, we'll focus on contrast.

In the top picture of a church in San Miguel de Allende, Mexico, the difference between the darkest and lightest parts of the scene is fairly wide. In the bottom picture of a quaint street corner in San Miguel, the contrast range is smaller than it was in the church.

Seeing the contrast range of a scene, and understanding it, will help you determine how many exposures you need to capture the full dynamic range of the image. That's covered on the next page.

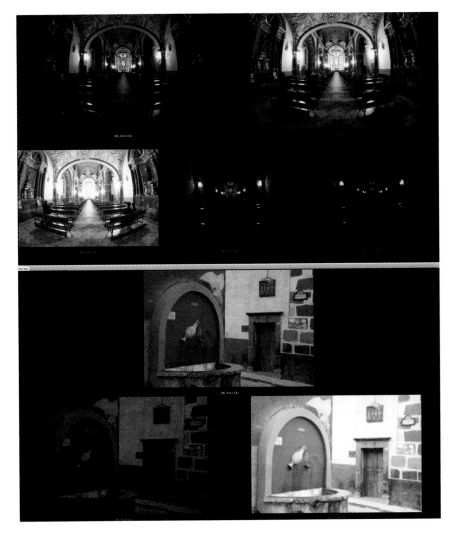

Too Few and Too Many Shots

Here are two screen grabs of the files I used to create the HDR images on the previous page. They are Adobe Bridge files.

For the top, high-contrast image, five exposures were needed to capture the dynamic range of the scene. I shot, using the exposure compensation feature of my camera, at the following settings: 0EV, +1EV, -1EV, -2EV and -3EV to capture a total of five exposures.

For my quaint-corner HDR images, I only needed three exposures: 0EV, +2 EV and –2EV.

The key to getting a good HDR image is not to take too few or too many images. Too few images will leave gaps in your dynamic range; yet the more images you take, the more chance you have of ending up with digital noise and chromatic aberrations (covered later in this chapter) in your images.

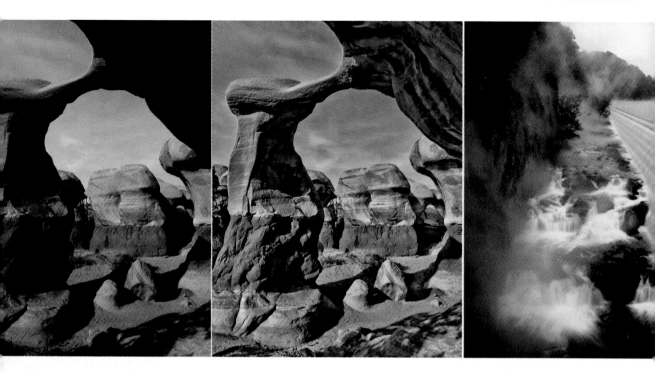

Spot Metering Can Help

If you are new to seeing the light, a spot meter can help you determine how many exposures you need to take for an HDR image. Most digital SLRs haves built-in spot meters. If your camera doesn't have one, spot meters are also sold separately. All spot meters measure the brightness of a small area (a spot) of a scene.

The Devils Garden, Utah, scene on the left had a lot of contrast. In this case, spot metering the sky and the darkest shadow would reveal that the scene has about a four-stop exposure difference—thus requiring four different exposures.

The scene of the New Croton Dam in New York has less contrast. Metering the sky and the water would tell you that there is about a three-stop exposure difference. This means three different exposures are required here.

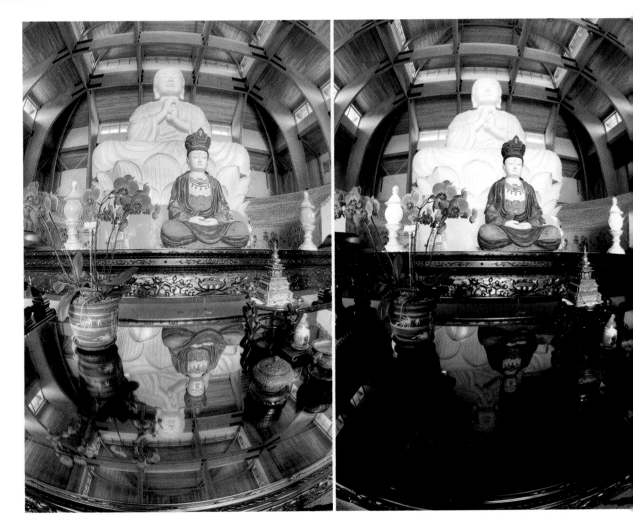

What Your Eyes See vs. What Your Camera Sees

Our eyes can see a dynamic range of about eleven f-stops; our cameras can only see a dynamic range of about six f-stops. That is why we need HDR photography—to capture the full dynamic range of a scene.

The HDR image on the left captures the wide dynamic range of the scene. The image looks pretty much the same as the actual scene looked to my eyes … but with a boost in saturation for an artistic effect.

The image on the right is the camera-recommended, average exposure of the scene. As you can see, the camera could not capture what my eyes saw, or what is preserved and revealed in the HDR image.

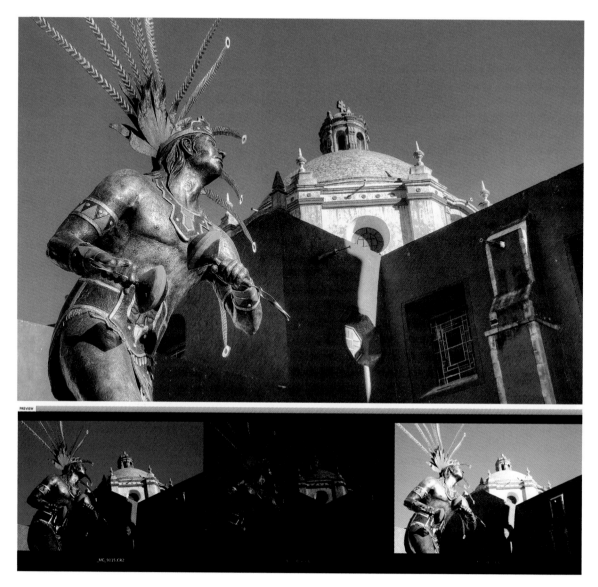

Check Your LCD Monitor

A good method for ensuring that you capture the entire dynamic range of a scene is to check your camera's LCD monitor.

Basically, you want to underexpose a scene so that none of the highlights are blown out (in this case, you're looking at reflections on the statue) and that none of the shadows are blocked up (think: shadows on the building). You can check these exposures by looking at your LCD monitor.

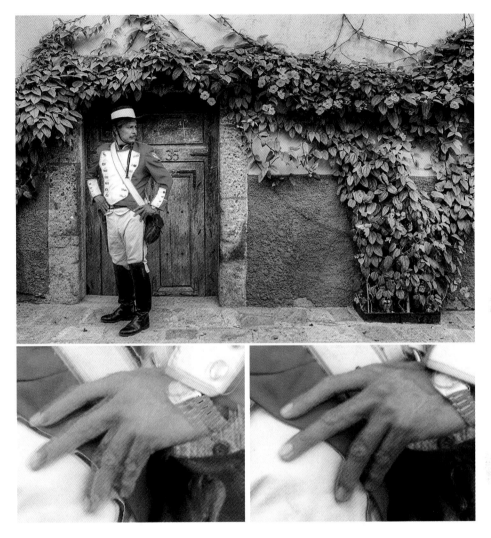

Auto vs. Manual Bracketing

When taking pictures for your HDR image, you'll either have your camera on automatic exposure bracketing (AEB) or you can manually bracket your exposures.

Either way, the end result is the same; but there are two factors to consider.

Automatic bracketing will be faster than manually bracketing, which means action will be frozen in the Auto setting if a subject moves—as did this police officer in San Miguel. You can see his blurry right hand (from another set of images) in the bottom left image.

Manual bracketing may be required if your camera does not offer the bracketing range that you need. Some entry-level and mid-range cameras only bracket two stops over and two stops under the average exposure. Professional cameras offer more.

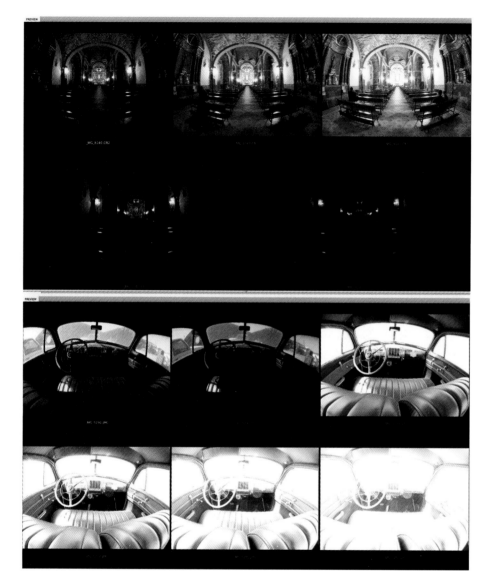

Look for Highlights and Shadows

When taking pictures for an HDR image, you don't always have to take the same number of exposures in the same directions and from the recommended exposures.

When there are many highlight areas in a scene, as in my San Miguel church picture on page 38, you want to take more exposures under the recommended setting in order to capture its entire dynamic range.

Similarly, when there are many shadow areas in a scene, as in my old car shot, you want to take more exposures over the recommended setting to capture the full dynamic range.

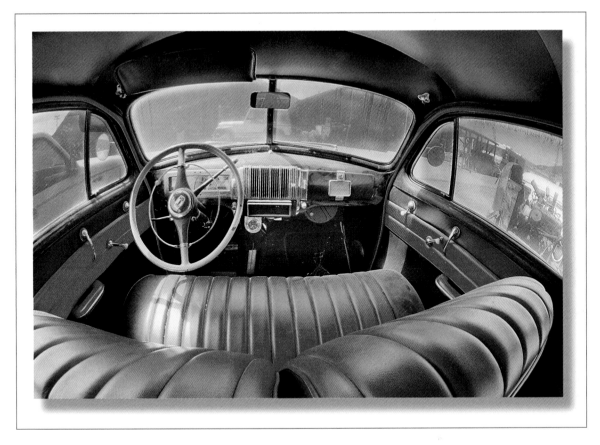

Careful Bracketing Pays Off

You saw the benefit of carefully bracketing my San Miguel church picture near the beginning of this chapter. Here you see the effect of carefully bracketing on my old car HDR image.

This is one of my favorite HDR images. (You'll hear me say that a lot in this book.) It's a favorite because there is so much to see in the image. The more there is to see, usually, the more interesting an HDR image.

Hey, if you like the presentation of this HDR image, try it yourself. Here is how I created the effect. In Photoshop, I used a Drop Shadow Layer Style. Then, also in Photoshop, I used the Stroke feature to create the red thin-line frame around the image. Easy peasy, lemon squeezy …

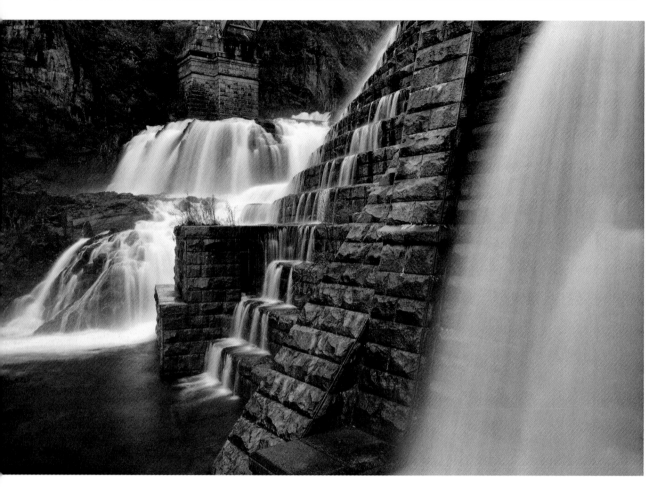

Movement Can Be Okay

On the previous page, you saw how even a slight movement can ruin a picture. Yet the effect of showing movement can be cool when it comes to an HDR image, especially when your subject is water and clouds.

This HDR image of the New Croton Dam was created from three exposures. My shutter speeds were between three and nine seconds for the set of exposures. This is what caused the cool effect of the blurred water.

Two-Image HDR Images

Most photographers take at least three exposures when shooting for an HDR image. My friend Joe Brady at the MAC Group has another suggestion: Look at the scene carefully. If the contrast range is not more than two stops, take only two pictures: one exposure for the highlights and one for the shadows.

I tried Joe's recommendation in the Villa de Santa Monica in San Miguel. It worked!

Follow Joe's advice combined with mine: Don't create an HDR image from more exposures than you actually need. If you do, as I mentioned before, digital noise and chromatic aberrations may creep into your image. This is covered more in a few pages.

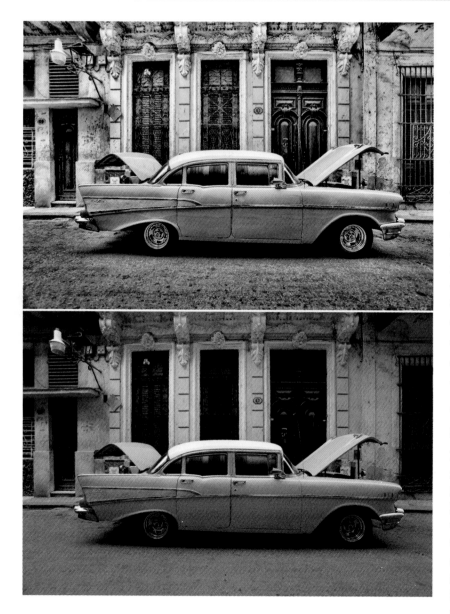

Pseudo HDR Images

HDR images include details in the shadow and highlight areas of a scene, and more texture than standard out-of-camera shots. Nothing beats a true HDR image. However, it's possible to create a pseudo HDR image from a single image using several different methods that are covered in this book.

The fastest and easiest way I've found is to use a plug-in called Topaz Adjust from Topaz Labs (www.topazlabs.com). That's what I used for my Cuban car image.

Do this by opening an image in Photoshop. Select the Topaz Adjust/Spicify filter and play with the sliders. Click OK, and you have an image that looks somewhat like an HDR image. Sure, some shadows will be blocked up and some highlights may be overexposed, but if all you have is a single image, then this is a cool method for creating the HDR look.

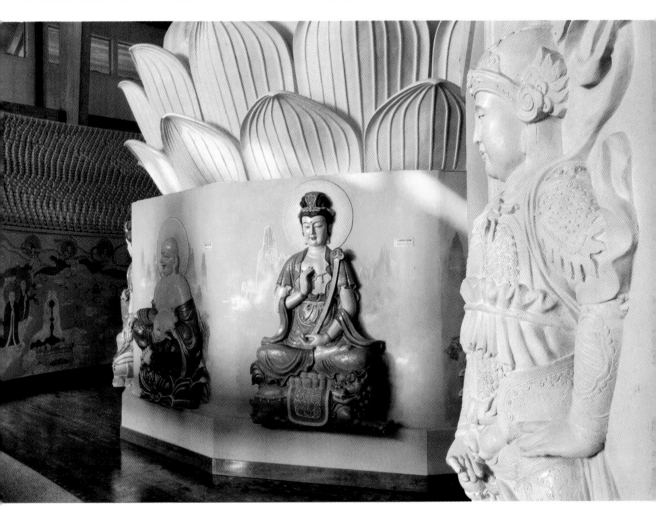

Aperture Must Remain Constant

In all HDR photography, you need to keep the aperture constant among your different exposure shots. This will help you maintain the same depth-of-field throughout your set of pictures.

This means you need to either shoot in the Aperture Priority mode or the Manual Exposure mode. In both modes, you can easily bracket your exposures without changing the aperture by changing the shutter speed or ISO.

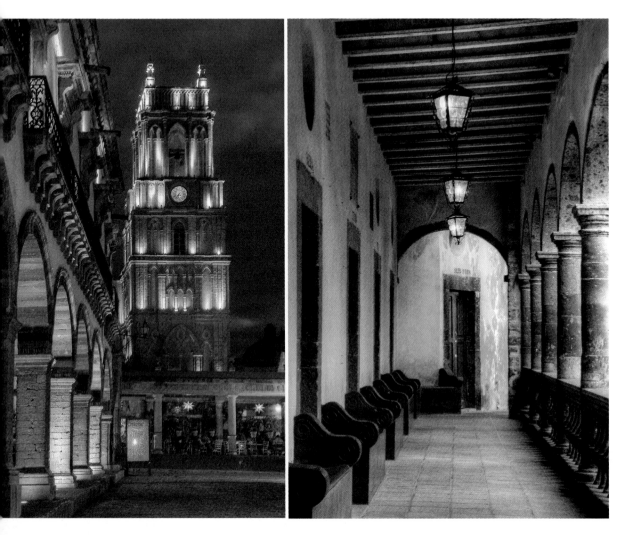

Carefully Focus; Manually Focus

While taking several exposures for your HDR image, it's not impossible for the focus to change—if you leave your camera on the auto focus mode. Focus shift is more likely to happen in lowlight situations (when contrast is low) and when there are different objects at different distances in the scene.

To ensure a consistent focus point in your set of pictures, you need to focus using the auto mode on your camera … or focus manually. Then, switch to manual focus—without changing the focus. This technique will ensure that all your pictures have the same focus point.

As with the aperture, if your focus point is a bit off, you can get a ghost image in your HDR photograph. Or the entire image could be ghosted, which will look like an out-of-focus picture. Not a good outcome …

Reduce Digital Noise

Digital noise is exaggerated in HDR images. This is because HDR photos are comprised of multiple images; and the more images you use, the more digital noise is compounded.

You can reduce digital noise, which shows up more in shadow areas and in plain areas (such as sky), by shooting at a low ISO setting. Note, too, that newer cameras produce lower levels of noise than older models, and DSLR cameras generate less noise than point and shoots.

Photomatix and Topaz, mentioned earlier in this chapter, offer noise-reduction features. You can also reduce noise in Photoshop, Lightroom, Aperture, Canon Digital Photo Professional and other programs. However, your best bet is to try to get the best possible in-camera image. The more time you spend on that, the less time you'll have to spend in the digital darkroom working on your pictures.

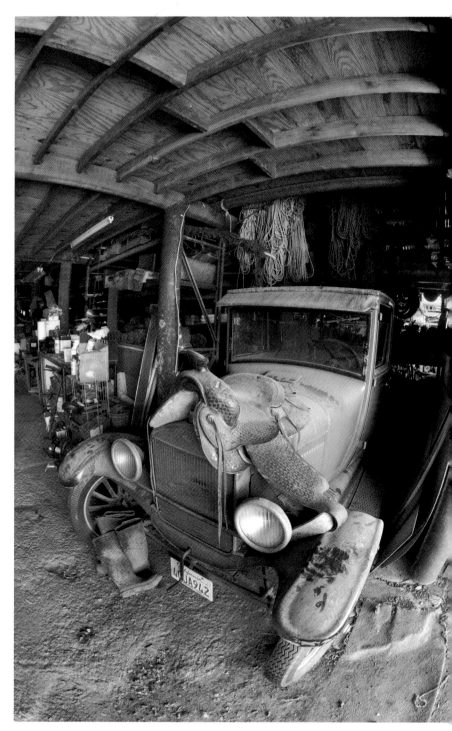

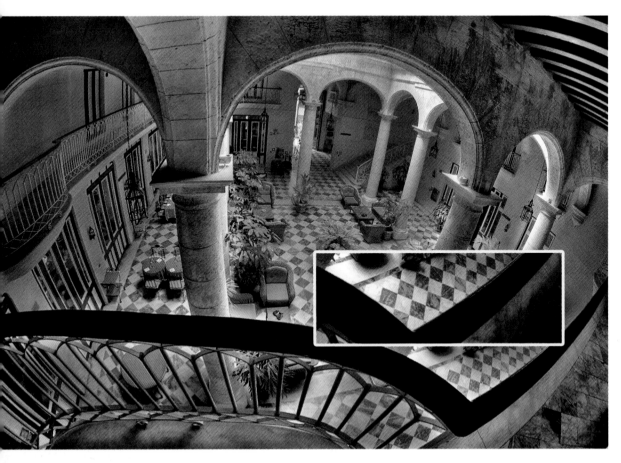

Check for Chromatic Aberrations

Chromatic aberrations are bands of red/cyan or blue/yellow that line areas of a scene where strong colors and strong contrast meet.

Like noise, chromatic aberrations creep into HDR images. As the number of photographs used to create an HDR image increases, so do the chances of getting chromatic aberrations.

I hate to ruin one of my favorite HDR images with a photo insert, but it illustrates the point. What's more, you saw this image in the Introduction to this book if you are reading in chapter sequence.

In the final image, there are no chromatic aberrations along the handrail. In the insert, you can clearly see the chromatic aberration.

While creating my final HDR image, I clicked on the Reduce Chromatic Aberration box in the Photomatix window. I will cover all this stuff later. For now, I just want you to be aware of chromatic aberrations.

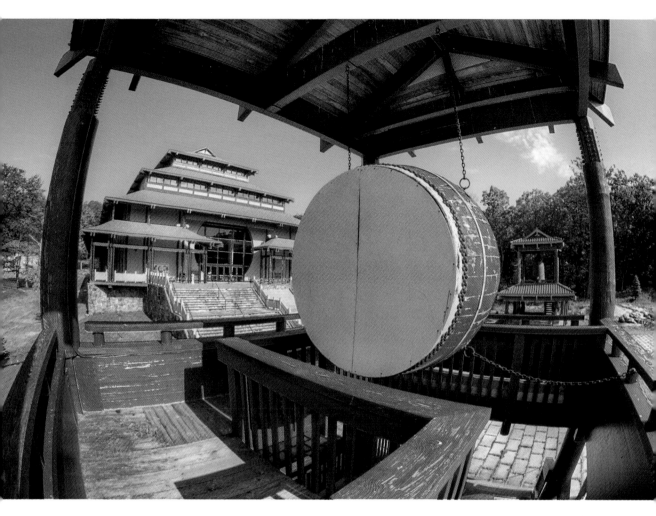

Steady Your Camera and Try Not to Touch

Earlier in this chapter we addressed subject movement. Sometimes it's bad (as in the man's blurred hand in the San Miguel image), and sometimes it's good (as in the New Croton Dam waterfall image).

Camera movement is almost always bad in HDR images. Steadying your camera with a tripod is the best way to avoid camera shake, which will usually occur at slow shutter speeds when you hand-hold your camera. But you want to steady your camera for another very important reason: You want all your pictures to line up exactly. That said, the align feature in Photomatix can be used effectively if there is slight movement between or among images.

I used a tripod for this HDR image of a Buddhist temple near my home in Westchester, New York. The tripod and camera created a shadow on the floor of the tower. I removed that shadow with the Clone Stamp tool in Photoshop.

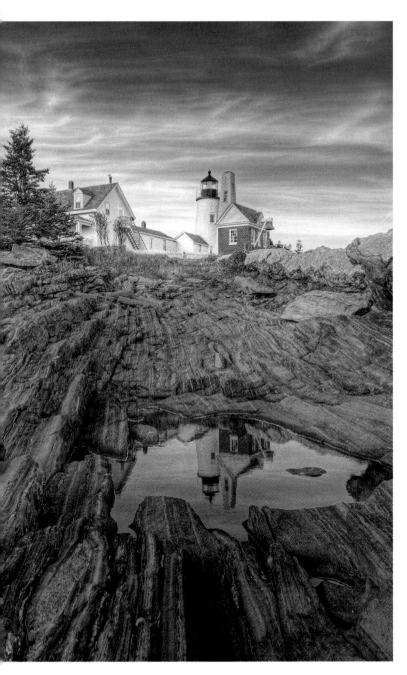

Hand-Held Images Can Work

As mentioned, a tripod is the best way to ensure a steady shot. That said, you might be able to get a sharp HDR image with several hand-held shots. Here is one example; it was created with several pictures that I took in Rockport, Maine.

Here is what you need to get a series of shots that line up as much as possible:

One, hold your camera very steady.

Two, select a relatively fast shutter speed—at least 1/125 of a second when using a wide-angle lens, which is the lens of choice for most HDR photography.

Three, use a camera with a very rapid frame advance (six frames or more per second). Entry-level digital SLRs and compact cameras don't offer as many frames per second. The slower the frame rate, the more chance you have of moving during the shooting sequence.

Basics are Essential

We've now covered most of the basics of HDR shooting, but there is something else that is very important to consider: Most of the fundamental skills of photography, including good composition, selecting an interesting subject, and *making* a picture rather than simply taking one—all covered in this book—very much affect the outcome of any specific technique, including HDR.

I made this picture by selecting the location, getting on site early to avoid traffic on the corner, and then asking the man to stand in position—simulating the effect that he was walking up the hill.

The point is: Don't rely on HDR techniques to create great images. You still need to use your head and good basic photography processes to make great pictures.

dSLR vs Compact Camera

Okay, I have to say it: Cameras don't take pictures, people do! To illustrate this point, this HDR image was created from a set of three pictures I took with my Canon G10. All the other images in this book were taken with my professional digital SLR cameras. I like this image. There's lots of detail in both the shadow and highlight areas of the scene.

When it comes to HDR photography, *you* are the most important factor—not your equipment.

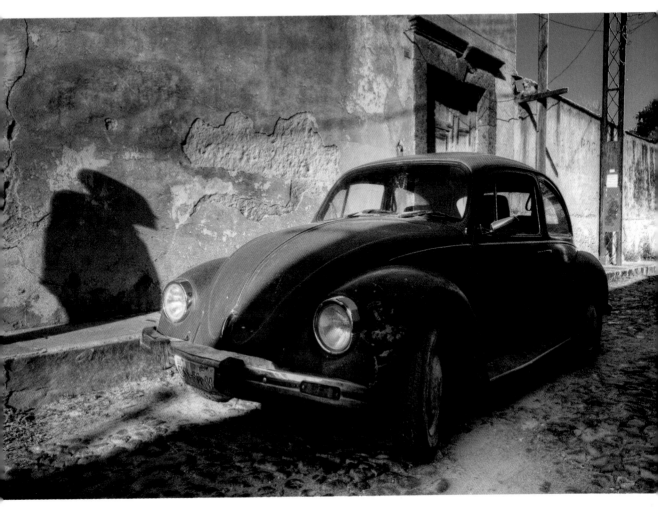

Sharpen Your HDR Images

All RAW files need sharpening. That's because they come out of the camera a bit flat ... to preserve details in the highlight areas.

All HDR files need sharpening, too. My preferred sharpening method is to use Unsharp Mask in Photoshop. I'll cover the technique in more detail later, but for now just know that if you want the best possible HDR image, you'll probably want to sharpen it. This will bring out all the details in the shadow and highlight areas.

HDR vs. RAW File Processing

Later we'll take a look at using standard Photoshop adjustments to expand the dynamic range of an image. One technique is to work in Adobe Camera RAW—by itself or in what's called *double processing* … or even *triple processing*.

Basically, from a single file, you create two or three images that, together, cover the entire dynamic range of the scene. Then you spend time, often quite a bit of time, blending the images into one HDR image. After that, you spend even more time using adjustment layers and other tools to create a final image that reveals higher dynamic range than the original photograph.

So that's an option if the dynamic range of a scene is not greater than a few stops … and you have a lot of time. But if the dynamic range is wide, you'll need a true HDR program to create an image that shows all the details in the shadow and highlight areas.

This Cuba doorway scene actually has a wide contrast range—from the outside of the building to deep within the hallway—as illustrated by the image below showing the result of an average exposure shot. I created the image to the right with Photomatix.

Speaking of time, check out the next tip.

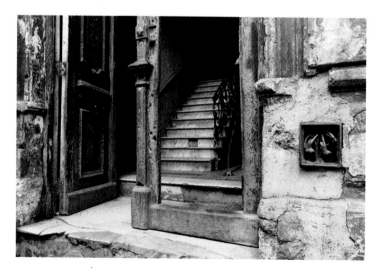

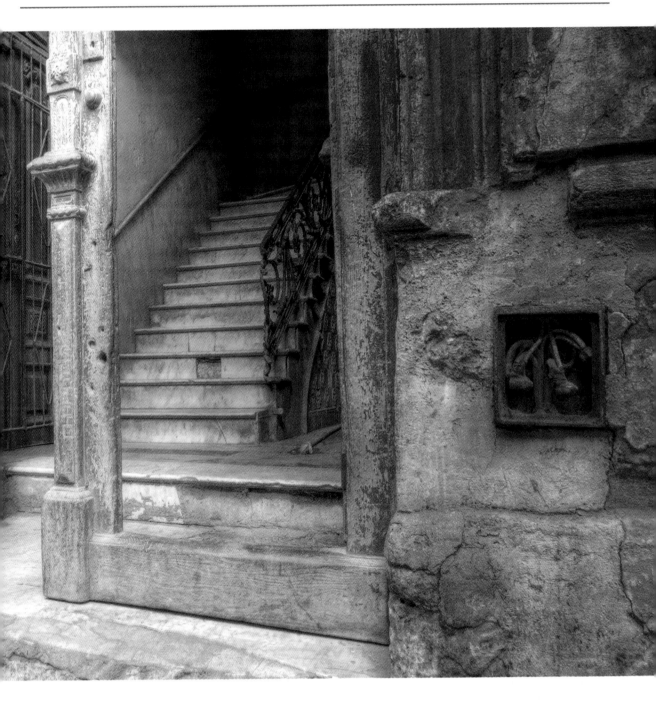

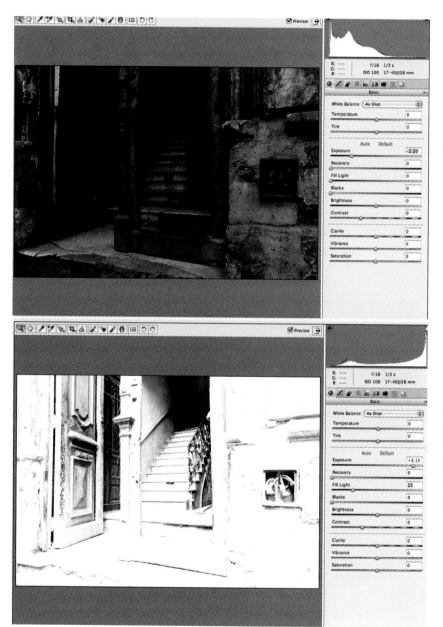

Faster with Photomatix

Following up on the topic of HDR vs. RAW file processing, here are two screen grabs from Adobe Camera RAW. The top shot shows the outside wall properly exposed, and the bottom shot reveals the detail in the hallway.

As I mentioned on the previous page, I'd have to spend a ton of time trying to create an HDR image in Photoshop from these two files alone. So much time that I wouldn't actually do it—and I don't advise you to do it because Photomatix is faster, easier and more fun!

But fear not. I will cover some basic, fast and fun techniques for expanding the dynamic range of a single image later on in this book.

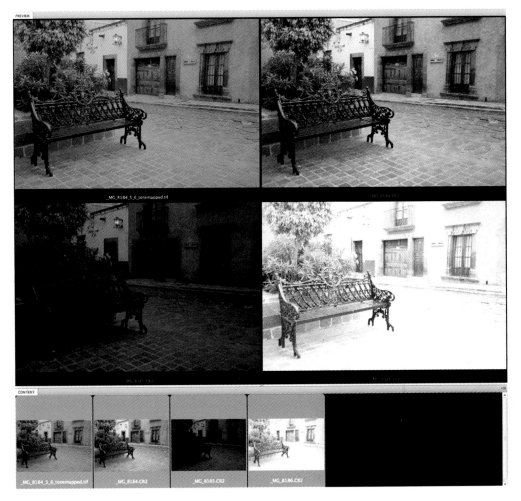

HDR File Management Suggestion

HDR photographers have many things in common: a love of HDR, a love of photography and a love of digital imaging. They also share something else: tons of files!

There are many file management systems. Here is one to save time when you get serious about processing your HDR images.

Put your sets of pictures in a folder. Then, generate an HDR image in Photomatix using those images—with Photomatix at its Default setting. The result: You'll have your set in a folder and your processed (tone-mapped) image in the same folder. When you are ready to tweak your tone-mapped image, all you'll have to do is drag it over to the Photomatix icon, where you can fine-tune your HDR image before working on it in Photoshop.

Here is a screen grab that shows you my three images from a shoot in San Miguel. They are filed with the tone-mapped image.

Separate Your Shots

Yikes! These are the worst photographs in this book. However, I think you will find them useful from an illustrative standpoint.

When you are taking sets of pictures for an HDR image, an easy way to separate the images is to take a picture of your hand between each set. That way, when you are scrolling through your files, you'll have an obvious divider between each set. If you don't use this technique, you may accidentally pick the wrong photograph, with perhaps a different setting, for your HDR image.

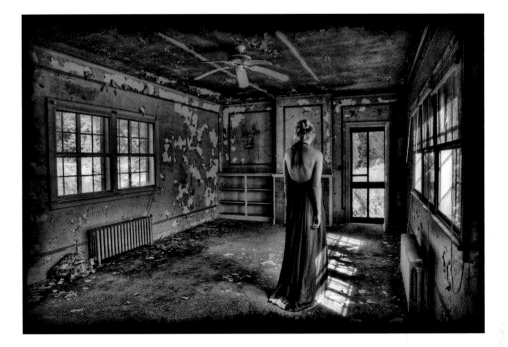

Part III

Photomatix: The Most Popular HDR Program

There is a reason Photomatix from HDR Software (www.hdrsoft.com) is by far the most popular HDR program available: It is powerful, affordable and easy to use. What's more, as you will discover, making HDR images with this program can help you awaken the artist within.

Photomatix can help you create different types of images, such as the artistic one that opens this chapter or the realistic one that closes it. Photomatix can also help you create a dramatic HDR image that has an even wider dynamic range than your eyes, as pictured on the last page of this chapter.

Here is the HDR image of my friend Chandler, whom you "met" earlier in this book. I dressed up this image by adding an Acid Burn frame from onOne Software's PhotoFrame Professional (www.ononesoftware.com). This is the artistic version of the image. It was created with Photomatix's Detail Enhancer. You'll see a more realistic version of the scene that was created from the same set of images in just a few pages.

This chapter covers the basics of Photomatix. Just keep in mind that the best way to get good at using this program is to play, play and play some more with the adjustment sliders. They are the keys to your creative potential here.

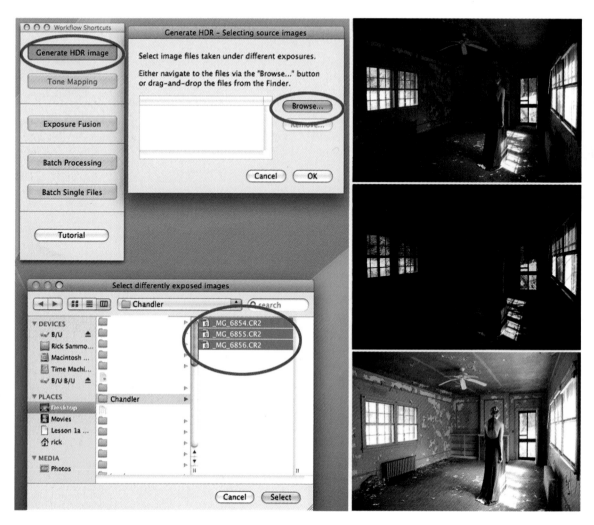

Getting Started

The first step in creating an HDR image in Photomatix is to put your pictures in a folder.

Next, open Photomatix and go to Process > Generate HDR Image. From here, you'll get a Browse window. Either navigate to the images or drag them into the Generate HDR – Selecting Source Images window.

In the lower-left screen shot, you see that I selected three images. These are the three images I took of Chandler in the abandoned house. With this done, you are almost ready to generate your HDR image.

There is more to Photomatix. Think Exposure Fusion and Batch Processing. We'll get to Exposure Fusion later … in a chapter of its own. Batch Processing is simple though. It's used to process multiple images (a batch) at the same settings. If you have a lot of HDR files to process, it will take quite a bit of time. So, select Batch Processing before you go to sleep!

Generate HDR: RAW vs. JPEG

The next step is to click on Generate HDR. However, if you shoot RAW files, which I recommend, you'll get the window you see in the screen grab on the left. It has more options than the window in the screen grab on the right, which is what you get when you shoot JPEG files.

The main difference between the windows is color control. In reality, color tools are not really a big deal, because you can tweak color in Photoshop … and also in other windows of Photomatix. Nevertheless, you really should shoot RAW files to get the most out of each image.

Next, click on Align Source Images, Reduce Chromatic Aberrations and/ or Attempt to Reduce Ghosting Artifacts. The last option is helpful if there is subject movement in the scene.

Keep in mind that noise and chromatic aberrations are the enemies of HDR, so look for them and try to reduce them in your images with these tools whenever possible.

Also know that the more boxes you check, the longer it will take the program to process your image.

In my experience, the average time to generate an HDR image from three files is about four minutes. That does not include any time you spend making adjustments, and this could take a long, enjoyable time if you are really into creating original images.

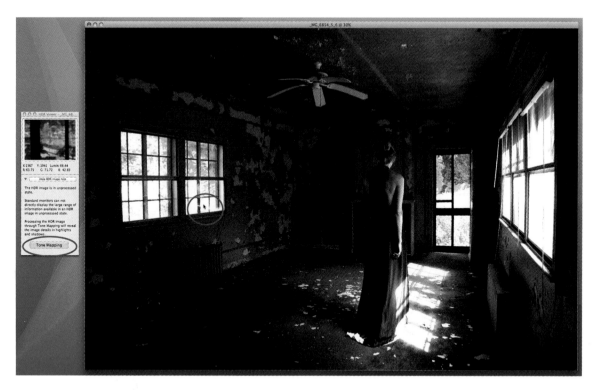

Don't Panic!

Yikes! What a strange-looking image, complete with blown-out highlights and blocked-up shadows.

Don't panic when your picture looks somewhat like this after all your hard work in the file and after you click "Generate HDR." This is totally normal. Your monitor just can't display all the brightness ranges (tones) in the scene. That is why you need to click Tone Mapping in the preview window. This will bring up the windows shown on the next page.

By the way, when you move your cursor over an area of an image in this window, you can get a preview of the HDR effect. As illustrated in the big image, you can't see any detail in the circled area of the window (but you can see my cursor). However, in the preview window, you can see details in the foliage outside.

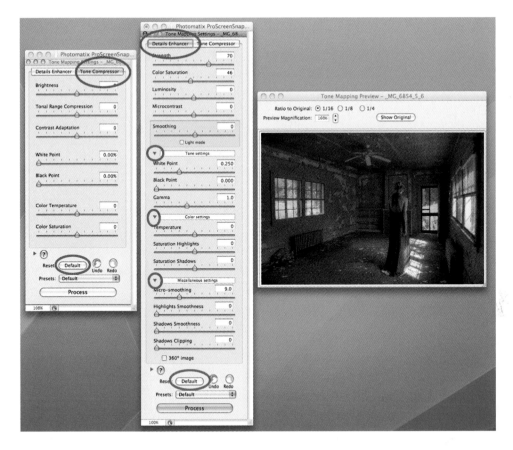

Taking Control of Your Image

After you click Tone Mapping, you'll get a window with tabs for both the Tone Compressor and Detail Enhancer. You can't see them at the same time, which is why two screen grabs are side by side to show them.

The Tone Mapping preview window also appears. It does not show your final image. You need to do some work, including going through the adjustments, to bring your HDR image to life. I'll go through those adjustments on the next page.

Note the circled triangles on the left side of the Details Enhancer window. I have them clicked to reveal the sub menus. I recommend that you work this way so you have fast access to the adjustments.

The Default buttons (also circled) in both windows are very important. You need to click on these buttons when you begin work on a new image. If you don't, the last batch of settings that you applied to an image will be your starting point for working on your next file.

Knowing this, if you love an effect and want to apply it to several images, do not click the default buttons. Instead, you can use the Presets button to save a set of settings that you want to use again and again.

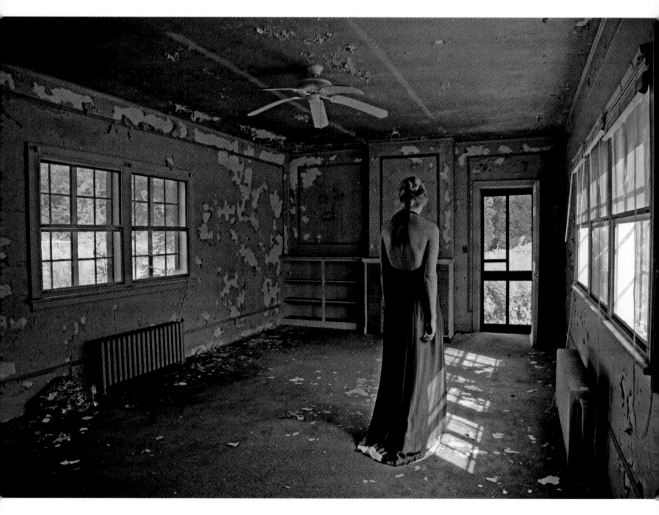

Tone Compressor for Realistic Images

On this spread is my Tone Compressor image of Chandler and a brief rundown of the adjustments available in the Tone Compressor window.

We'll start with Tone Compressor, because this is where you really should begin your HDR work. It's here that you compress the tones in a photograph to create a realistic image.

If you are happy with the results you get with Tone Compressor, simply click *Process* and then click *Save*.

If you want a more artistic image, you'll move on to Details Enhancer—covered on the next spread.

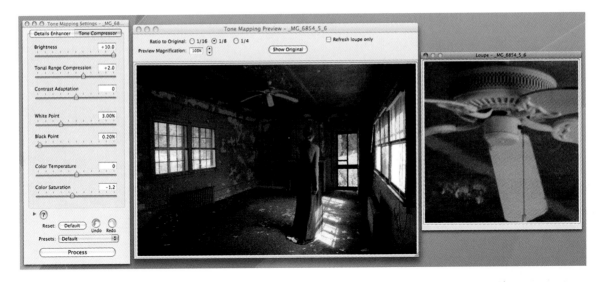

Tone Compressor Adjustments

Okay, here's a look at the Tone Compressor adjustments. Before we get going, the picture of Chandler looks dark because I have the Tone Compressor set at the Default setting. I have not yet worked on this image.

To zoom in on an area, click inside the image. That opens the Loupe preview window, shown on the right side of this screen grab.

You can move the windows around your desktop simply by clicking on the bar at the top of the windows. The adjustments:

- Brightness: Moving the slider to the left darkens the image; moving it to the right brightens it.
- Tonal Range Compressor: Moving the slider to the right opens up the shadows; move left to darken them.
- Contrast Adaptation: Slide to the right to increase the contrast; move left to decrease it.
- White Point: This sets the white point. Moving the slider to the right brightens the lightest part of the scene; moving it to the left darkens it. More on this adjustment is coming up in a few pages.
- Black Point: This sets the black point. Move the slider to the right to darken the picture; move it left to brighten the picture.
- Color Temperature: This is similar to white balance. Moving the slider to the right warms the picture; moving it to the left cools it.
- Color Saturation: Moving the slider to the left decreases the saturation; moving it to the right increases saturation.

Again, playing with these sliders is the best way to learn about them. There is no magic formula.

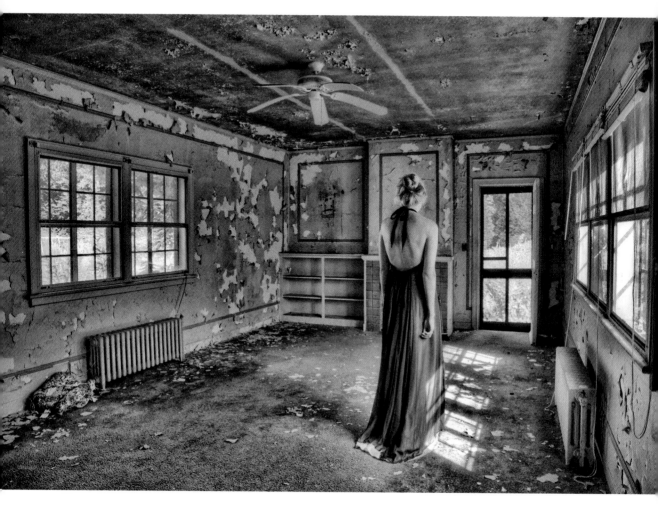

Details Enhancer for Artistic Images

On this spread you'll find my Details Enhancer image of Chandler and a brief description of the adjustments in the Details Enhancer window. If you want to create wonderfully artistic images, you've come to the right place.

As I mention throughout this book, playing around with the sliders is the best way to learn about each adjustment.

Enjoy!

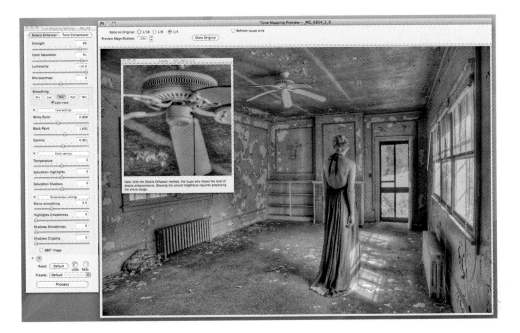

Detail Enhancer Adjustments

Here is a brief rundown of the adjustments available in the Detail Enhancer window. Basically, moving the slider to the left reduces the effect and moving it to the right increases it. Again, I have the Loupe window open to provide a close-up view of a specific area of the scene. This image looks a bit different from the image on the opposite page because it's a screen grab. The adjustments:

- Strength: Controls the intensity of the effect.
- Color Saturation: Affects the intensity of colors in the image.
- Luminosity: Controls the overall brightness of the scene.
- Micro Contrast: Used to adjust the contrast of the scene.
- Light Modes/Smoothing: Smoothes out the contrast range between the dark and light areas of a scene. More on this topic is on the next page.
- White Point and Black Point: See description on Tone Compressor page.
- Gamma: Controls the mid-tones. Moving the slider to the right brightens and flattens the image; moving it to the left darkens and increases contrast.
- Temperature: See description on the Tone Compressor page.
- Saturation Highlights and Saturation Shadows: Controls the intensity of the highlight and shadow areas of the scene, independently.
- Micro-Smoothing: Move this slider to the right to reduce noise and give a picture a more natural look.
- Highlights Smoothness and Shadows Smoothness: Moving these sliders to the right reduces contrast in the respective areas.
- Shadows Clipping: Reduce noise in the dark shadow areas of the image by moving the slider to the right.

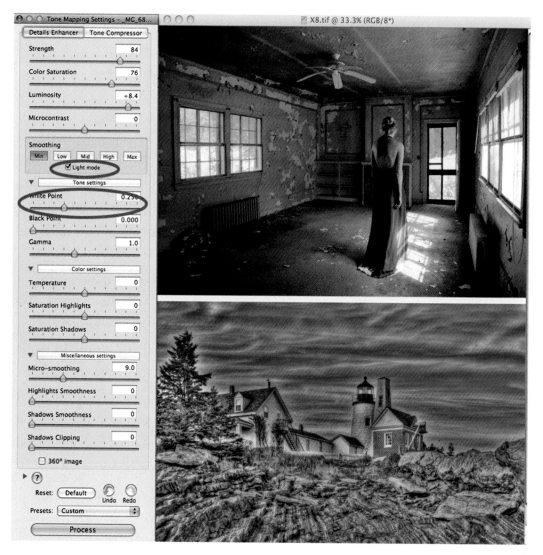

Watch the White Point and Light Mode/Smoothing

Two very important adjustments are the slider to control White Point and the Light Mode/Smoothing adjustment. If you don't use them wisely, your images could look like these.

The top image has blown-out highlights, because the white point was set too far to the right.

The bottom image has some unnatural-looking halos around areas where dark and light areas meet. This is most noticeable on the tree on the left. The effect is the result of the Light mode being set to Minimum (on the left). I set that adjustment to Maximum (on the right) when I created the picture on the opposite page.

Be very careful with all the slider adjustments; be especially careful with these.

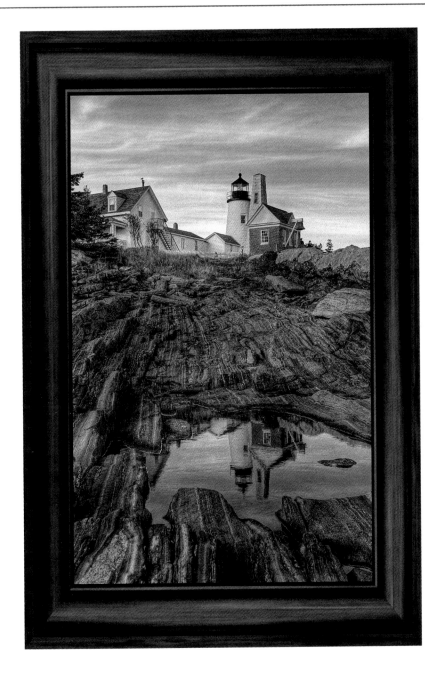

Suitable for Framing

This is one of my favorite Photomatix/Details Enhancer images. It was one of my first experiments with HDR. It took about an hour to create the desired effect, because I was learning the program.

I am sharing this with you to offer hope! Don't get discouraged with HDR if you are new to the process and it doesn't come quickly. It takes some time to understand and master this technique. However, the time is well spent. Once you know the basics, you'll be able to create HDR images like this in 20 minutes or less.

Just for fun, I added the digital frame with onOne's Software's PhotoFrame Professional (www.ononesoftware.com).

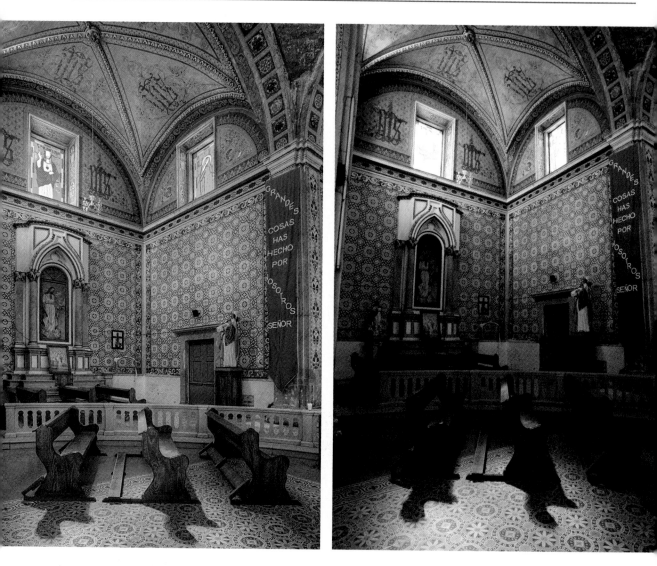

The Subject Often Dictates the Effect

In this chapter you saw both realistic and artistic HDR images. Some photographers like both effects; some like one more than the other. But usually, the subject dictates the best effect.

In this example, realistic seemed to be the best choice for depicting the interior of this old church in a small town outside San Miguel de Allende, Mexico.

Compare the before and after images, and see how many more details are revealed in the HDR image on the left.

As a side note, I corrected the perspective distortion of the image (which was caused by tilting up my camera with a 17mm lens) with the Transform Perspective feature in Photoshop CS and CS4.

Part IV

Pseudo HDR Single Files with Photomatix

Earlier, we explored how to create true HDR images with Photomatix, a cool and easy-to-use program. Here, you'll learn how to use Photomatix to create a pseudo HDR image from a single photograph.

Those single images, by the way, should be RAW files. Yes, you can convert JPEG and TIFF files to 16-bit files in Photoshop (Mode > 16 Bit) and use them to create pseudo HDR images. Keep in mind, however, that you'll get much better results from RAW files.

In some cases, when the contrast range is not greater than three stops, a pseudo HDR can look as good as a true HDR image. For example, can you tell which one of these images, taken at a ghost town near San Miguel de Allende, Mexico, is a pseudo HDR image and which one is a true HDR image? Okay, I'll tell you; the one on the left is the pseudo HDR.

Sure, there is no substitute for a true HDR image when the contrast range is extreme. But you'll see that you can create some really cool pseudo HDR images in Photomatix when the contrast range is manageable. What's more, if you have only recently gotten into HDR photography, try to create pseudo HDR images on your old RAW files. You will be surprised at the results. And this process will help you practice HDR techniques.

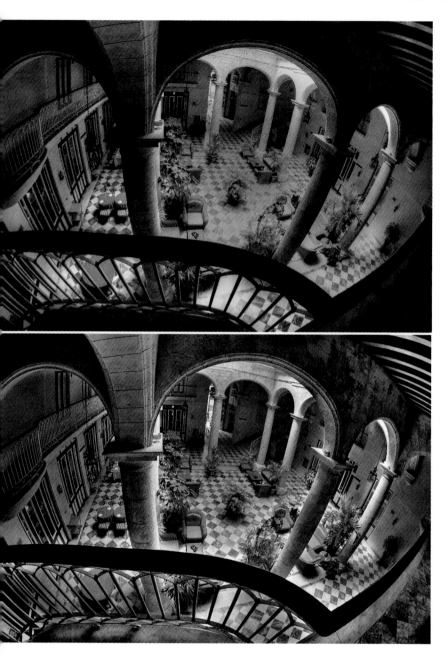

Contrast is the Determining Factor

On the previous page, you saw that it was hard to tell a pseudo HDR image from the true HDR image. That's because the contrast range was not very wide in the photograph.

But check out this pair of images. The top image is the pseudo HDR image, and the true HDR image is on the bottom. Not only is part of the top image overexposed (look at the top of the far columns on the right), but chromatic aberrations have crept into the photograph. As you saw earlier, this can be reduced when you create a true HDR image. The top image also looks a bit flat.

Sure, I could have spent some time in Photoshop to fix the pseudo HDR image. But shooting a series of pictures for an HDR image and processing the HDR image in Photomatix is easier and more true to life than fiddling with a single-exposure in which the contrast range is too great.

Contrast is the determining factor for choosing the best process to create the HDR effect.

Starting Point

The first step in creating your Photomatix pseudo HDR image is to simply drag your file—a RAW file or a converted 16-bit file—on top of the Photomatix icon on your desktop. As an option, you can go to File > Open on the Photomatix Menu bar at the top of your monitor.

When your image opens in Photomatix, it will look like the top image, which is totally normal. Again, as explained in the chapter on creating true HDR images in Photomatix, you need to tone map your image. To do that, go to the Photomatix Menu bar on the top of your monitor, and then go to Process > Tone Mapping.

After playing around with the controls—as you would when working on a true HDR image—your image will take on the look of an HDR image … with more texture and details than a straight file.

This image was taken in an antique shop near Rockport, Maine.

Different Options

When creating a pseudo HDR image, you'll have some of the same options that are available to you when creating a true HDR image. You'll also have some different options. For instance, after you select Tone Mapping for a pseudo HDR image, you'll get the same Tone Mapping controls as you do when creating a true HDR image: *Tone Compressor* and *Detail Enhancer*.

What you will not see are the options for reducing noise and chromatic aberrations and for changing the white balance. No worries though; you can do all this in Photoshop.

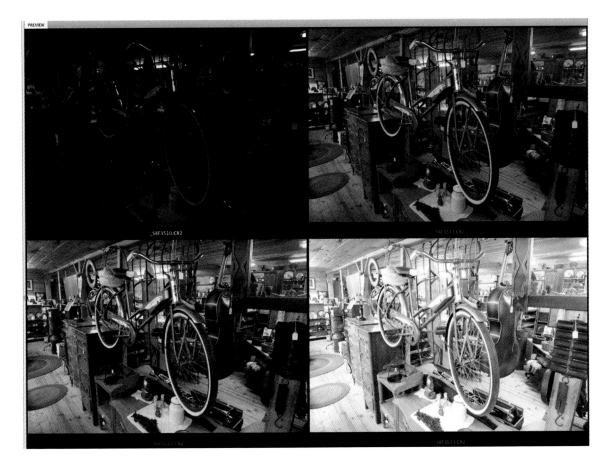

Better Safe than Sorry

Here are the four images I took in the antique shop to create a true HDR image. I'm glad I took the time to shoot these. And my advice to you is to do the same. When you are not sure about which way to go: true or pseudo HDR, and you have a tripod, the time and free space on your memory card—go for the true HDR files.

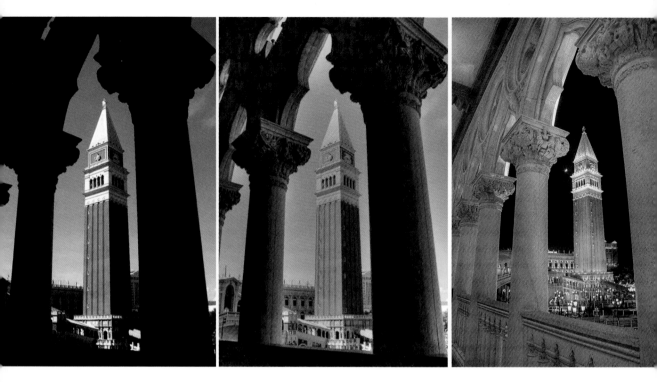

JPEG to HDR?

In the page opener for this chapter, I mention that it is possible to create a pseudo HDR from a converted file: RAW, JPEG or TIFF. I also mention that you'll get the best results from a RAW file, because it contains the most information.

The middle image is a pseudo HDR image that was created from a JPEG file (middle). Sure, we can see into the shadows, but the shadow areas are pixilated now, and there is a glow around the columns. What's more, there is a loss of detail in the tower.

The left and middle pictures illustrate two points: 1) If you are going to create a pseudo HDR image, use a RAW file; and 2) Sometimes a non-HDR image is better than an HDR image, even an HDR image that's created from a set of images. Why? Because deep shadows can add drama to a scene, and the hidden detail, in some cases, are more meaningful than a fully revealed scene.

The picture on the right is a Photomatix HDR image, taken at night when the contrast range was even greater than it was during the day. Check out all the details. Yes, that's the moon in the image.

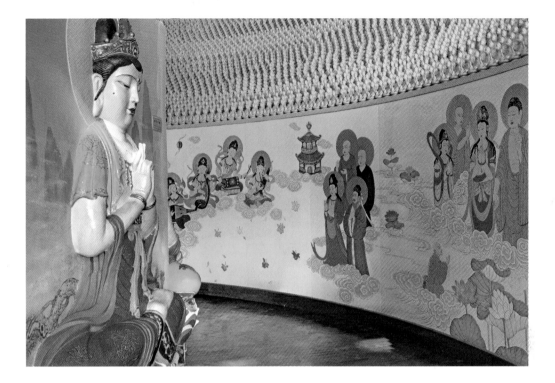

Part V

Exposure Fusion with Photomatix

The two previous chapters described processes for creating true HDR images and pseudo HDR images using Photomatix. Here is another HDR technique to add to your choices: Exposure Fusion with Photomatix.

Exposure Fusion is a quick HDR fix. It's super fast and easy, because it's basically automatic, and there aren't any tone mapping controls to maneuver. In fact, an Exposure Fusion image can be created in about a quarter of the time it takes to create a true HDR image.

Sure, speed and ease are big advantages, but keep in mind that there is no substitute for true HDR imaging … when a scene you're capturing has a strong contrast level.

I'll say it again: Contrast level is the key. If the contrast range is relatively low, as it was in this area of a Buddhist Temple, then Exposure Fusion can do a great job enhancing a photograph. In fact, it can do an even better job than what sometimes results from playing around with RAW files in Adobe Camera RAW. It can't, however, compete with true HDR imaging.

In this chapter we'll explore the pros and cons of Exposure Fusion.

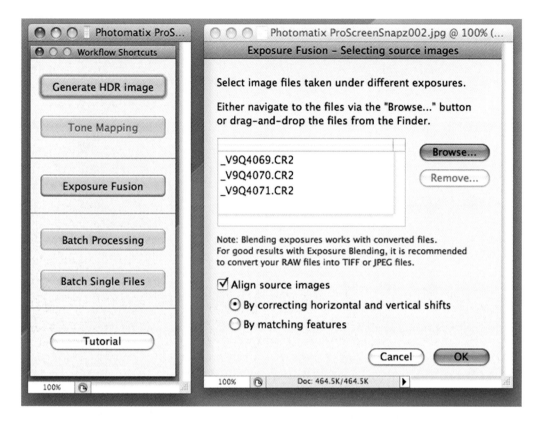

Launching Exposure Fusion

After you open Photomatix, go to Process > Exposure Fusion. Click on the Exposure Fusion button, and you'll get the *Exposure Fusion – Selecting Source Images* window. Select your images by either dragging them in to that window or browsing for them.

Click "Align Source Images" if you think there is any movement in your set of pictures. That goes for true HDR imaging, too.

After you click OK, Photomatix gets to work on creating the image.

Before we move on to the Exposure Fusion preview window on the next page, it's important to know how Exposure Fusion images differ from true HDR images. To create an HDR image with Exposure Fusion tools, you still need to shoot a set of photographs at varying exposures as previously described.

The Exposure Fusion process produces images that look more realistic and natural than true HDR images. Yet they tend to look a bit flat. Therefore, they require some tweaking in Photoshop, Lightroom or Aperture.

A benefit of Exposure Fusion is that noise is not increased in your image, as it usually is when creating a true HDR image. This is good to remember when working in low-light situations.

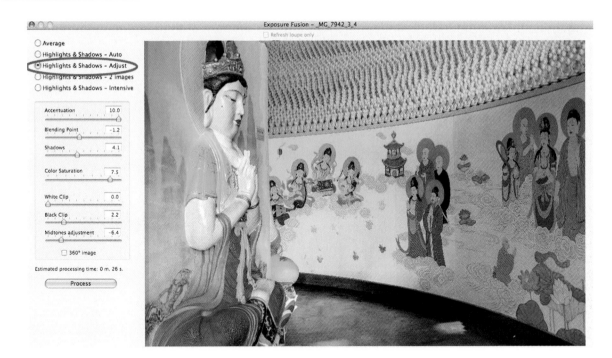

Adjusting Your Images: Highlights & Shadows Adjust

You have several methods for adjusting your image in Exposure Blending; each option is in a different window. These adjustments are listed below and on the following page.

You will find that working with *Highlights & Shadows – Adjust*, one of five options listed on the left side of the window, offers much more control than the other Exposure Blending options. In fact, it's the only Exposure Blending option I use.

Basically, moving the sliders to the right increases the effect; moving them to the left decreases the effect. Here is a look at the controls in the Highlight & Shadows Adjust window.

- Accentuation: Changes the strength of local contrast enhancements

- Blending Point: Affects the weighting given to the underexposed versus overexposed parts of an image

- Shadows: Changes the brightness of the shadows without affecting the highlights

- Color Saturation: Allows you to manipulate the saturation of the color channels

- White Clip: Specifies how much the highlights are clipped
 Note: Moving the slider to the right increases contrast but removes details in the brightest highlights.

- Black Clip: Specifies how much the shadows are clipped
 Note: Moving the slider to the right increases contrast but removes details in the darkest shadows.

- Midtones Adjustment: Positive values brighten the image but reduce the overall contrast. Negative values darken the image but increase overall contrast.

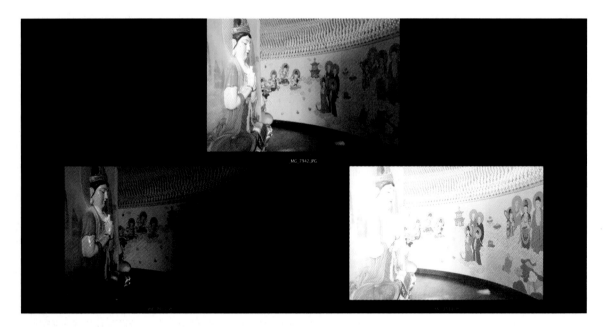

Adjusting Your Image Part II

Here are the three photographs I used to create the opening image for this chapter. I took exposures at 0EV, +1 EV and –1EV. As you can see in the opening image, Exposure Blending helped out big time!

Below is a quick look at the other creative adjustment options in Exposure Blending: *Highlights & Shadows – 2 Images* and *Highlights & Shadows Intensive*. Note the control—or rather lack of it—these options offer.

By the way, *Average* and *Highlights & Shadows Average,* the top choices in the control window, offer no control. Skip 'em.

Highlights & Shadows – 2 Images blends only two images. The dialog allows you to select which images are blended. *Highlights & Shadows Intensive* offers the following adjustment options:

• Strength: Adjusts the weight of local contrast enhancements

• Color Saturation: Adjusts the intensity of the color channels

• Radius: Controls the area used to calculate the weighting of the source images. A higher radius reduces halos, and increases processing times significantly.

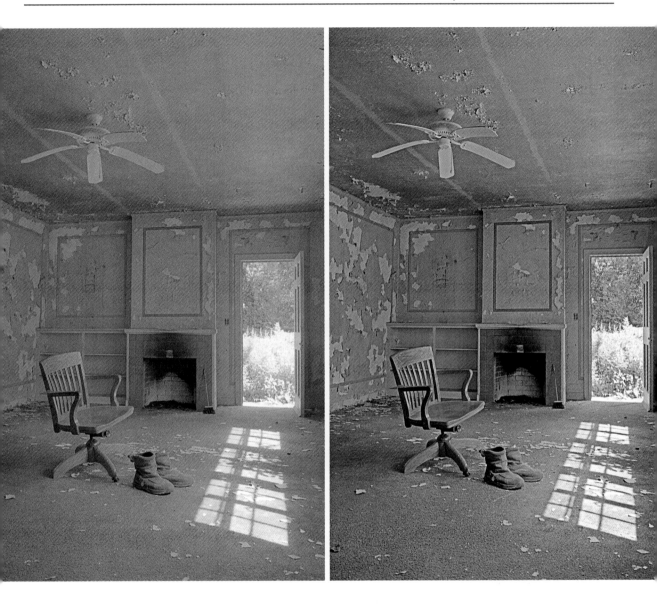

Exposure Fusion with Help from Photoshop

As mentioned earlier in this chapter, Exposure Fusion images tend to look a bit flat. See the image on the left. That's not really a problem. With some basic Photoshop adjustments (covered later in this book), you can turn a flat shot into a much cooler image. See image on the right. To create that image, I simply boosted the contrast, saturation and brightness (using Levels in Photoshop).

Still, there is no substitute for true HDR. Do I say that often enough?

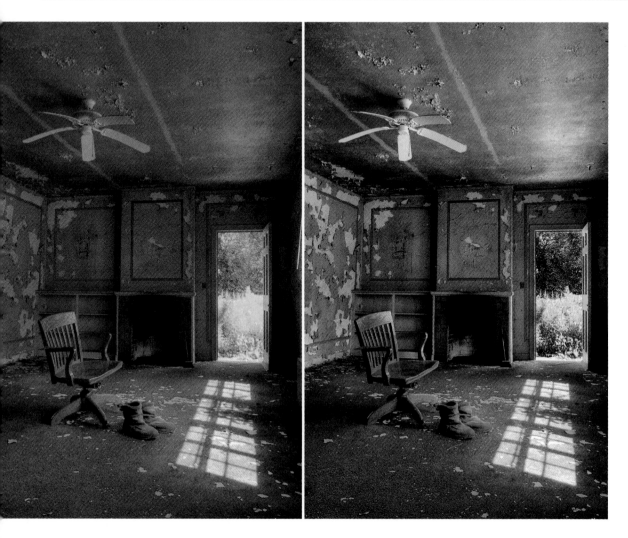

True HDR with Help from Photoshop

On the left is a true HDR image, generated from the same set of images that I used to create the Exposure Fusion image on the previous page. It's pretty nice. However, I felt it still needed some Photoshop adjustments, so I got to work. The image on the right is a result of boosting the contrast, saturation and brightness (using Levels).

I also did something else: I thought and worked selectively. Look at the doorway in both images. In the Photoshop-fixed shot, I reduced the saturation and increased the contrast. This provided a clearer view of the backyard. In the HDR image, that area is oversaturated, and oversaturation can mean lost details. In fact, oversaturation in all types of images can cause a loss of details.

The message: Most, if not all, Exposure Fusion and true HDR images need a little help from Photoshop (or Aperture or Lightroom).

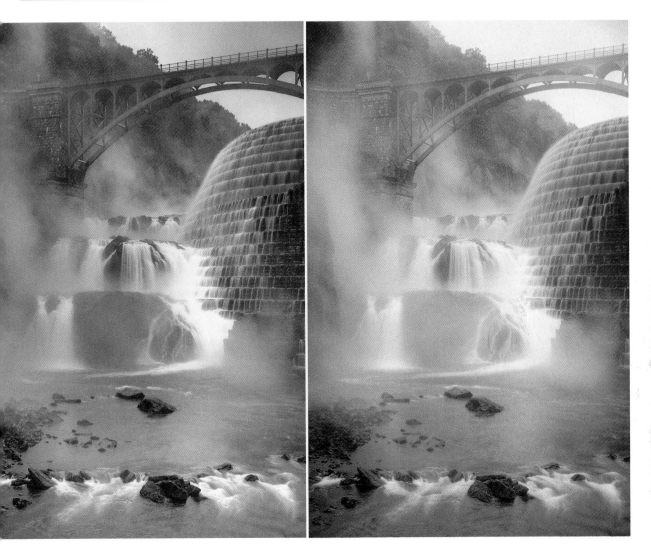

Look Closely and Carefully

Check out these two images, and look closely at the sky and white water.

In the Exposure Fusion image (left), the sky is unevenly exposed and part of the white water is overexposed.

In the true HDR shot, the sky is more evenly exposed and the water is correctly exposed.

Once again, the true HDR image looks better than the Exposure Fusion image.

Even if you think the contrast range is low, as it was in this case, you still may need to create a true HDR image for the best results. This is because the bright areas of a scene (the water and sky in this case) are Exposure Fusion image-killers.

Here is one of my favorite Exposure Fusion images. I chose to use Exposure Fusion in this case because, as I mentioned at the opening of this chapter, it's a fast and easy method for creating an HDR image.

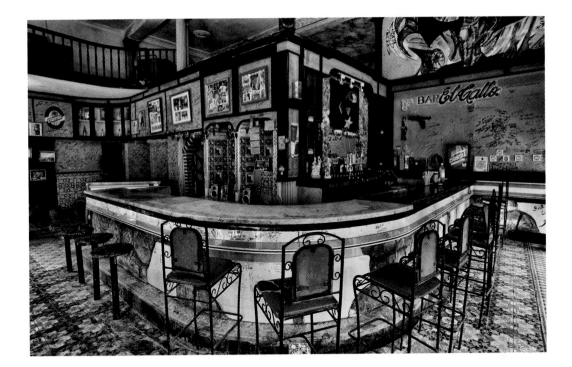

Part VI

Enter Topaz Adjust

We have been exploring techniques for creating true HDR photographs as well as pseudo HDR photographs. Now we'll explore how to expand the dynamic range of a single image using Topaz Adjust, a plug-in from Topaz Labs (www.topazlabs.com).

Before we get started though, you should know that Topaz Adjust cannot expand the dynamic range of an image to the extent of Photomatix. In fact, you could probably arrive at the same creative place with an image using Topaz Adjust as you would if you are very skilled at using Adobe Camera RAW and Photoshop … or even Lightroom or Aperture.

What Topaz does, behind the scenes and often with just a click of your mouse, is this: It expands/increases the contrast range, color range and detail range of a single image. Hey, who said HDR only applied to exposure?

This shot of a bar in Old Havana, Cuba, is packed with color and detail. What's more, it looks as though the lighting was fairly even, resulting in an even exposure. Check out the original, untouched RAW file on page 91. There, I'll tell you what I did not like about the image and how Topaz Adjust worked its magic.

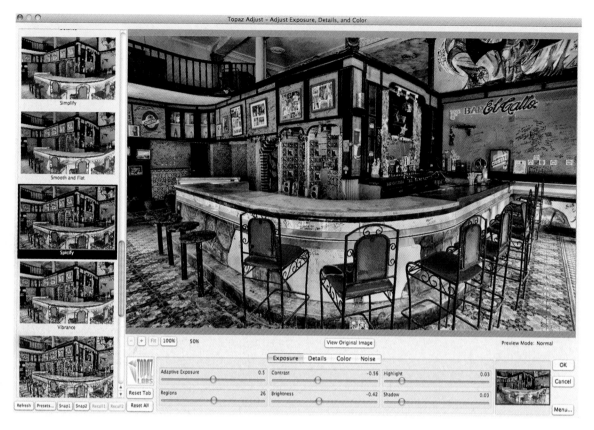

Topaz Command Center

After you download Topaz Adjust, its icon will show up at the bottom of your filter menu in Photoshop. You can also access Topaz adjust through Lightroom.

When you select Topaz Adjust, you get this window: the Topaz Adjust Command Center, as I call it. On the left side of the window you'll find 21 presets, accessible by using the scroll bar. If you like an effect, simply click on it. To fine-tune the effect, use the sliders under the preview window. Moving a slider to the right increases the effect. Sliding left decreases the effect.

As far as workflow goes, I like to go though the tabs from left to right: Exposure, Detail, Color and Noise. To check an effect, I click the *View Original Image* button. When I am satisfied with an effect, I click the OK button to apply it.

For the opening image of this chapter, I chose the Spicify effect, my favorite effect in Topaz Adjust.

Important: Click the *Reset Tab* and/or *Reset All* buttons to get back to the default settings when you've finished working on an image file. If you don't, your last choice of an effect will be applied to the next image you work on. This, of course, could be a good thing if you really like the effect.

Improving an Image

Here is my original Cuba bar shot. What a cool place … and what a flat photo. Compare the exposure of the floor at the bottom right of the frame to the exposure of that area in my Topaz Adjust image. In the Topaz Adjust image, you'll find more detail and color, because the area is no longer overexposed.

Also check out the writing on the face of the bar in my Topaz Adjust image. In that image, you can clearly see the writing. In the original image, most of it is lost.

All these improvements were done with the preset Spificy effect. How cool!

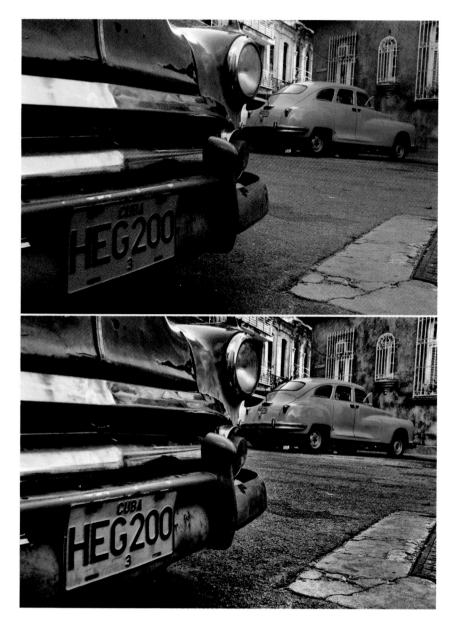

Dramatic Differences

You can create a dramatic difference when applying Topaz Adjust to an image, as illustrated here. I simply applied the Spicify effect to one of my Cuba car photographs. Check out the increased color, detail and saturation in the bottom image. Some photographers love the artistic images that can be created quickly and easily with this plug-in. I know I do!

Other photographers like a more subtle difference. Check out the next page.

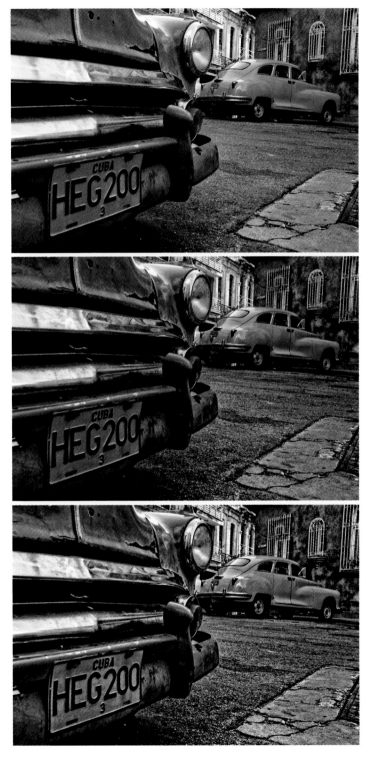

Subtle Differences

Here you see a more subtle approach to using Topaz Adjust on the Cuba car image.

From top to bottom, I applied the following effects:
- Clarity
- Small Details
- Spicify with a 50 percent reduction in Saturation

Here is a serious tip: Play with those sliders!

Speaking of being serious, if you are serious about getting good color in your pictures, consider this: We see colors differently after having a drink with alcohol or caffeine. Stress and being tired also affects how we see color.

When you are printing your images, don't drink and print. (Ha ha.)

Here is something else about printing: It's important to calibrate your monitor and printer, and to keep the light in your digital darkroom constant.

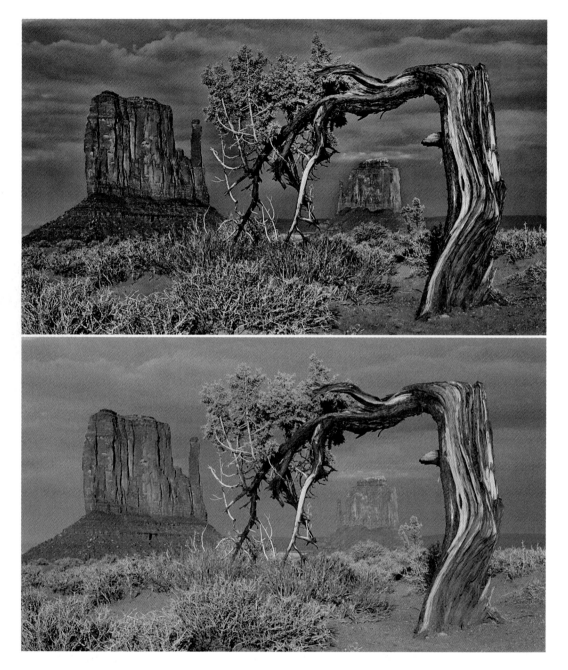

Add Drama to a Landscape

For years, I liked the bottom photograph, which I took in Monument Valley. I still like it! However, the version that shows the effect of Topaz Adjust/Spicify is also one of my favorites, because there is more drama in the sky and more detail in the foreground and background.

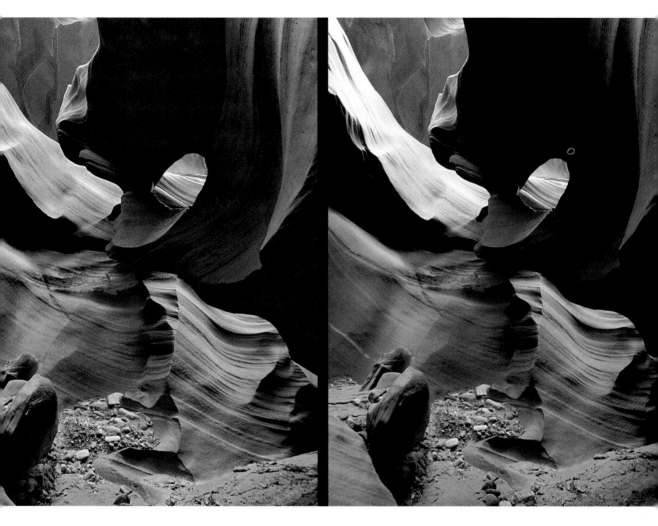

With a Little Help from Photoshop

As I mentioned, Topaz Adjust cannot create a true HDR image. That's where Photoshop (or Aperture or Lightroom) comes in.

My original picture, taken in Lower Antelope Canyon in Utah, is on the right. As you can see, part of the scene is overexposed and washed out.

Topaz did a pretty good job of bringing out some of the shadow detail, but it could not rescue the overexposed area. To save it, I used the Burn Tool in Photoshop.

I also used another contrast-reducing technique: I cropped the picture. Even the Burn tool could not save the overexposed area in the top-left part of the scene. Cropping it out produced a more evenly exposed image.

The Beauty is in the Details

In 2004, I explored Antarctica. That's when I took the bottom image. In 2009, I was exploring different Topaz Adjust effects on one of my favorite images from that trip.

Here I used the *Small Details* effect to bring out the details in the beautiful ice. By increasing the details in the scene, the image takes on a more dramatic look.

Awaken the Artist Within

Although the folks at the Ice Hotel in Quebec, Canada, gave me a warm welcome, it was still a chilly experience to stay there.

While photographing the structure, I felt an appreciation for the artists who created it. That gave me the idea to create an artistic image from my straight shot. The top image was created with the Topaz Adjust Spicify effect.

Play with Topaz and awake the artist within.

Highly Dramatic Color

The image on the right, taken in Old Havana, Cuba, looks like a photograph. The image on the left looks more like a painting. The difference is the Topaz Adjust Spicify effect. I used it to increase the color for the image on the left, boosting the saturation a bit more than I normally would.

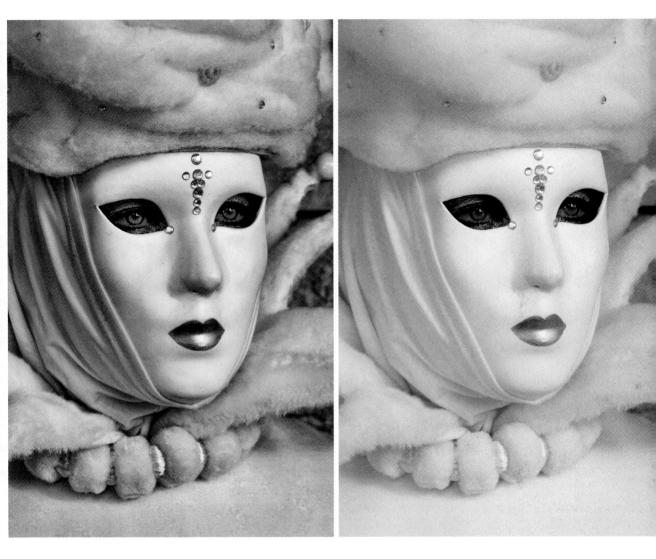

Creating Color

On the previous page you saw how the Topaz Adjust Spicify effect intensified the color in the image. On this page you see that the same effect can actually create cool colors … even when the color is white.

Personally, I like the straight shot—which I took in Venice, Italy—better than the Topaz Adjust image. But if the image was going to be used for an album cover or an ad, an art director might prefer the more colorful image.

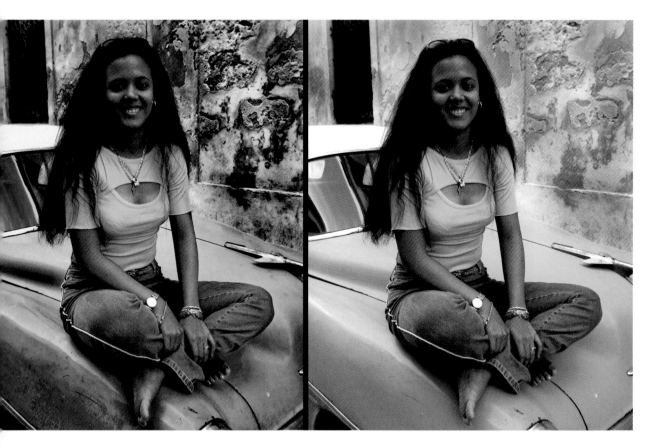

Apply Topaz Adjust Selectively

Compare these two images. The picture on the right is the straight shot. The picture on the left is my Topaz Adjust/Spicify image. You'll notice that the effect was only applied to the car and wall, and not the woman. Had I applied the effect on her, she would have looked pretty weird; strong and unflattering details would have shown on her face and body.

Applying Topaz Adjust selectively is easy. Here is a simple method. In Photoshop, duplicate your layer. Apply Topaz Adjust to the top layer. Now, use the Erase Tool to erase the effect on the area of the image that you want to retain.

Again, that is an easy way to apply Topaz Adjust selectively. A more professional method is to use *Convert to Smart Filters* in Photoshop to mask out the effect where it's undesirable.

The Softer Side of Topaz Adjust

Up until now in this chapter, we've focused on bringing out the details in an image. Well, Topaz Adjust has a softer side, too.

The more you reduce the noise, the softer your picture becomes. To create the soft picture on the right, I reduced the noise way beyond the setting I normally use. I checked the *Use Topaz deNoise* box.

Check out the softer—and perhaps more artistic—background and foreground. What about the subject that basically looks unchanged? Once again, I used the selective approach that's described on the previous page. In this case, I erased the effect completely on her face and other parts of her body that are showing. I only partially erased the effect on parts of her dress.

Expect Surprises

Here is a closing tip on using Topaz Adjust: *Expect Surprises*. To get those surprises though, you need to experiment with all the different effects and sliders.

This image was a total surprise. The original was tack sharp. By experimenting with the deNoise effect mentioned on the preceding page, I created this paint-like image. What a surprise! What fun.

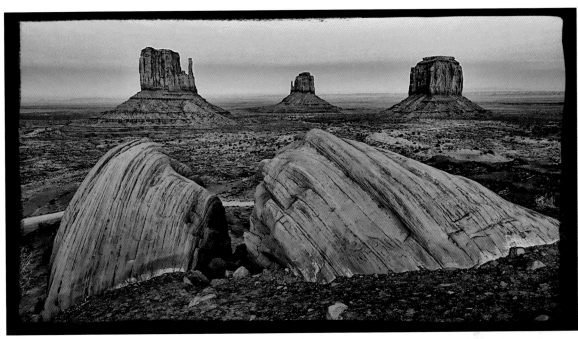

Topaz Adjust: Exposure Correction
onOne PhotoFrame Professional: Acrylic Brush

Part VII

Photomatix Meets Topaz Adjust

Congratulations! You have gotten through most of the HDR tech talk in the book. Yes, there is more to come, but I thought I'd give you a break and show some examples of how I applied Topaz Adjust to my Photomatix images.

These images are not intended to look like straight photographs. I just played with my photo files—something I encourage you to do, too.

While you are playing, here is something to think about: When you remove the true color from a scene, you remove some of the reality. The same is true when you increase or decrease the sharpness of an image; you alter a viewer's sense of reality. When you remove or alter the reality in a scene, your images become more artistic.

On each page of this chapter, I share the name of the Topaz Adjust effect that I used. You'll also find the name of the digital frame that I used from the PhotoFrame Professional program from onOne Software (www.onOnesoftware.com). I added the frames—you guessed it—for added fun! The frames also package the image in a way that makes it appear complete.

Enjoy.

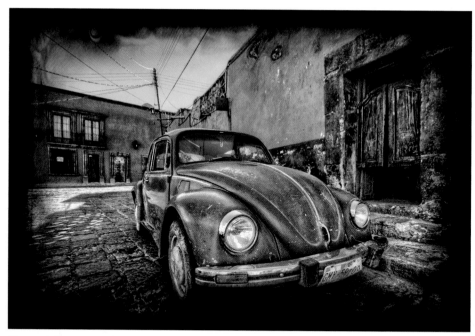

Topaz Adjust: Details
onOne PhotoFrame Professional: Grunge/Neutral

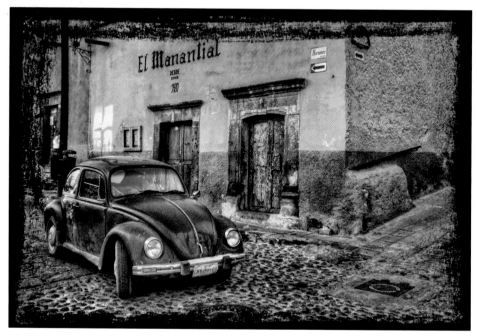

Topaz Adjust: Spicify
onOne PhotoFrame Professional: Brushes/Charcoal

Topaz Adjust: Portrait Drama
onOne PhotoFrame Professional: Man Made

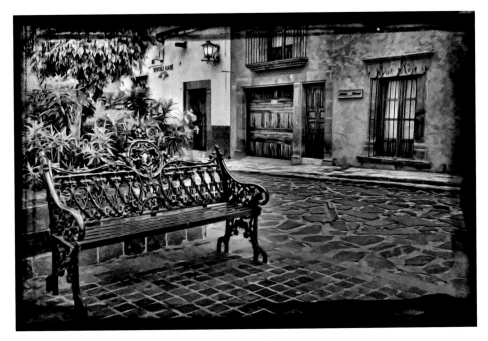

Topaz Adjust: Spicify (with noise greatly reduced)
onOne PhotoFrame Professional: Camera

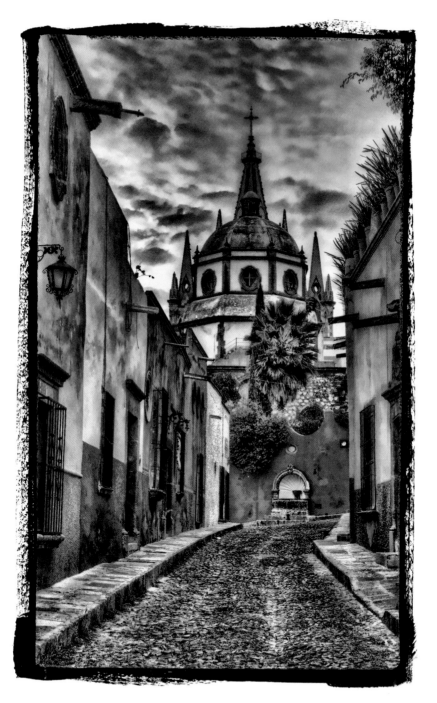

Topaz Adjust: Exposure Correction
onOne PhotoFrame Professional: Clean Inner Edge

Topaz Adjust: Exposure Correction (with saturation reduced)
onOne PhotoFrame Professional: Clean Inner Edge

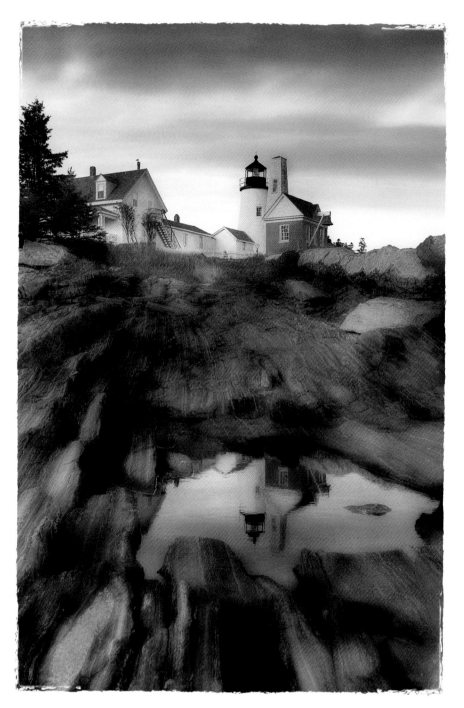

Topaz Adjust Portrait Smooth
onOne PhotoFrame Professional: Jack Davis

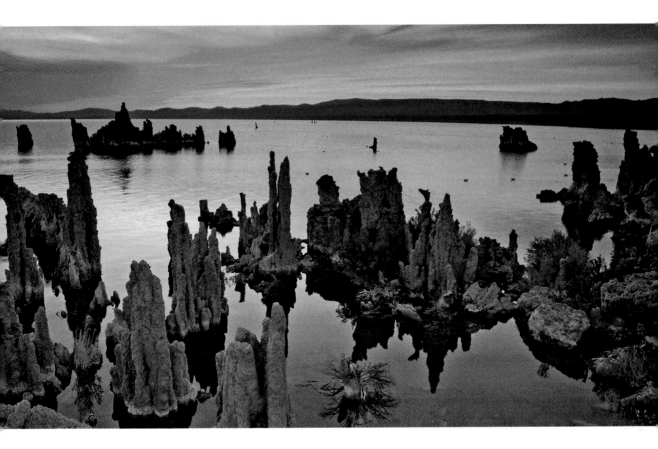

Part VIII

Expanding Dynamic Range in Photoshop

Look ma! No HDR program or HDR plug-in! That's right, HDR fans. This image was created in Photoshop with basic adjustments that were applied with adjustment layers.

Sure, the dynamic range of the image was expanded. But compared to some of the other images in this book, the dynamic range of the actual scene was not very wide. Still, to achieve a realistic image, the dynamic range had to be expanded.

On the following pages is an overview of the Photoshop process I used to create the image.

Keep in mind that if the dynamic range of your scene is within three f/stops, you can manage it in Photoshop. If it's greater than that, you really should use Photomatix.

I took this image at sunrise at South Tufa on Mono Lake in California.

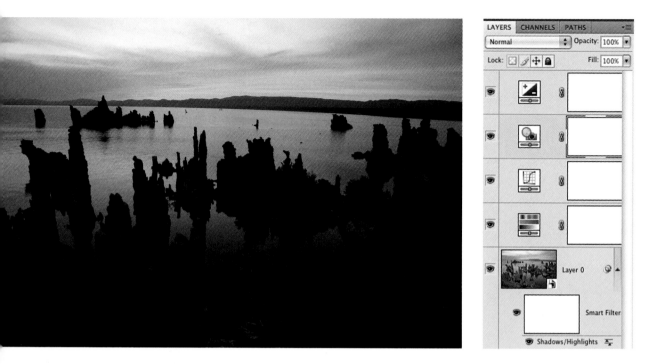

Adjustment Layers are the Law

Here is my original digital image. The light at sunrise was nice, but not for a straight photograph.

Before digital photography, if I had loaded my camera with slide film, I would not have taken this picture. At the time this was captured, I was able to envision the end-result, knowing the capabilities of Photoshop. I took the shot … and man o' man, am I sure glad I did!

Also on this page is a screen grab of the Layers panel. It shows all of the adjustment layers and layer masks that I created to enhance the image.

If you are new to Photoshop, it's important to know that an adjustment layer is a method of applying an adjustment to an image without working directly on the original file. Your adjustments are placed on a covering layer. That way, your original image always remains untouched.

After you apply an adjustment, you can mask out the effect. Just set black as the foreground color in the Tool Bar, and click on the layer mask. Then, just use the Brush tool to paint over the area that you don't want affected by the effect.

To create the image on the opening page of this chapter, I used the following adjustment layers, which show up in the layer panel (from bottom to top) Shadows/Highlights, Hue/Saturation, Curves and Photo Filter.

As a final step, I sharpened the image using Unsharp Mask. You always want to apply sharpening as the final step, because other adjustments—such as Curves, Levels and Brightness/Contrast—also affect sharpness, and the last thing you want to do is over-sharpen an image.

Basic Adjustments, Big Improvement

Here is a screen grab of all my adjustment windows. You see them here together; but when you are working on an image, you'll only see one at a time. I made this screen grab just for your convenience.

All these adjustment layers are accessible by going to Layer > New Adjustment Layer. The one exception is Shadows/Highlights.

The Shadows/Highlights adjustment is not readily available as an adjustment layer. You need to know this trick to make that happen: Click on the background layer of an image while holding down the Control key on your keyboard, and then choose *Convert to Smart Object.*

When working on my image, I opened up the shadows and toned down the highlights using Shadows/Highlights. I increased the saturation and color using Hue/Saturation. And I brightened the image using Curves. I then added some more color with the Photo Filter. As a final step, I sharpened the image using Unsharp Mask.

Note that you can use Unsharp Mask as an adjustment layer if you first go to Filter > Convert for Smart Filters. An advantage of this technique is that you can apply sharpening to certain parts of the image. In this picture, the parts I selected for the effect were the tufas (rock formations) and not the sky and water.

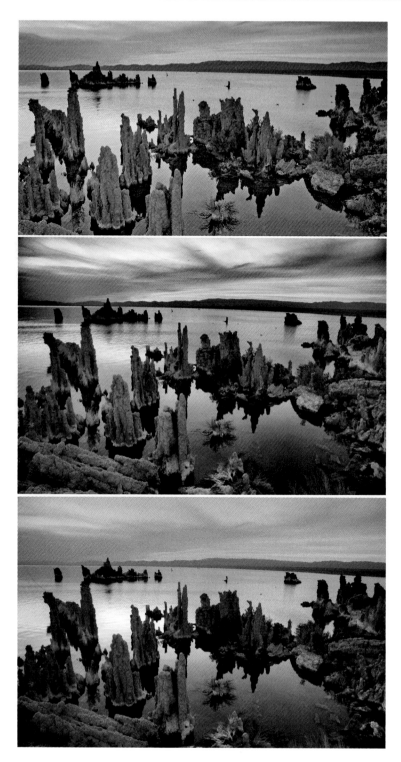

Photoshop vs. Photomatix Pseudo HDR vs. Topaz Adjust

Again, here is my Photoshop image.

Just for fun, I'll also share a Photomatix Pseudo HDR image (middle) that I created from my original image. Also take a look at a Topaz Adjust/Exposure Correction image (bottom) that I created from the same file.

If I had wanted to spend the time, I could have tweaked the Photomatix image and the Topaz image to look like the Photoshop picture. The key word here is *time*. You need to decide whether or not you have the time, and the desire, to work on an image until you are satisfied with the end result.

It also depends on your skill level. I have been using Photoshop for more than 10 years. Expanding the dynamic range of this image took less than 10 minutes. Ten years ago, it might have taken 10 hours!

Oh yeah, you will notice that I cropped my Photoshop image to eliminate some of the grasses in the foreground. I crop most of my images—for impact and to draw more attention to the main subject.

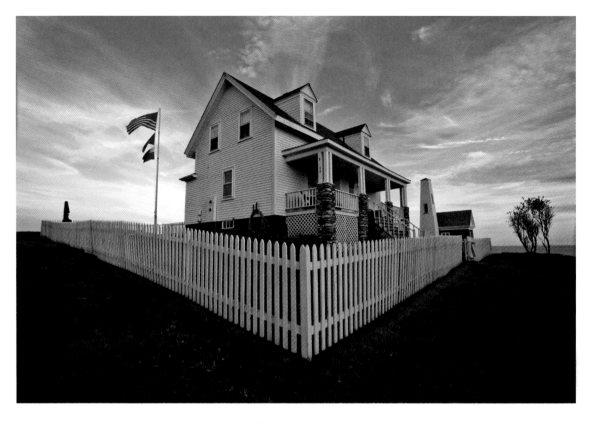

Part IX

Expanding Dynamic Range in Adobe Camera RAW

Creative options for expanding an image's dynamic range keep on coming. In addition to using Photmatix, Toapz Adjust and Photoshop, you can create HDR images with Adobe Camera RAW (also known as ACR), which is part of Photoshop.

Many professional photographers do most, if not all, of their work (straight work, that is—not HDR work) in ACR, because it is so powerful. It allows you to save some highlights and pull out some detail from the shadows in an image. And that is just the start. The enhancements and adjustments are almost unlimited when you go through all the ACR adjustment tabs and their sub menus. For now, however, we will only work with the Basic tab, the default tab you get when you open an image in ACR.

This is a picture I took of the Pemaquid Point Light (which most people call a lighthouse) in Maine during one of my workshops. Although I did take three pictures for a Photomatix image, I expanded the dynamic range of this image using ACR on a single image. Read on.

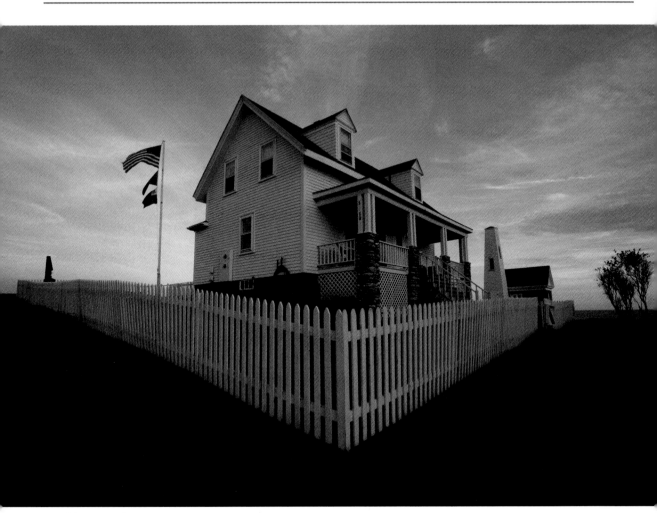

Exposing for the Highlights

Here is my original image. Although this is not a good exposure, it is the best in-camera exposure I could have taken at the time. The light was not great and I exposed the image for the highlights—in this case, the clouds.

When I shoot digital, I shoot as though I were shooting film, which means exposing for the highlights. If the highlights are more than one f-stop overexposed in an image, it's very difficult (if not impossible) to rescue them in the digital darkroom.

ACR Preview Window and Basic Tab

Here is a look at ACR's Preview window and the Basic tab within that window. To the right of the window is a screen grab of the Basic tab that shows the adjustments I made. Compare the numbers in the boxes (as well as the position of the sliders) to see the difference in the adjustments.

Basically, I used the Exposure slider to brighten the image and the Recover slider to tone down the highlights. The Fill Light slider helped to open up the shadows, and the Blacks slider added some contrast to the image. The Contrast slider was used to add even more contrast to the image, and the Vibrance slider helped add some vibrance to the colors that were not saturated in the image. Finally, the Saturation slider helped me to increase the overall color saturation of the image.

After making these quick adjustments, I pressed "Done" and I was… done! It was that fast and easy.

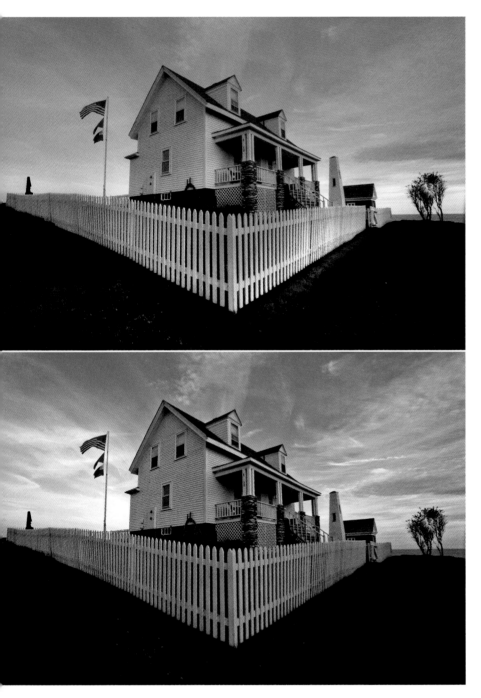

ACR vs. Photomatix

Once again, I'll show you a comparison between two images. The top photograph is the Photomatix HDR image created from three images. The bottom is my ACR image.

If I had wanted to play with my Photomatix image in Photoshop, I could have increased the saturation and contrast a bit to match my ACR image.

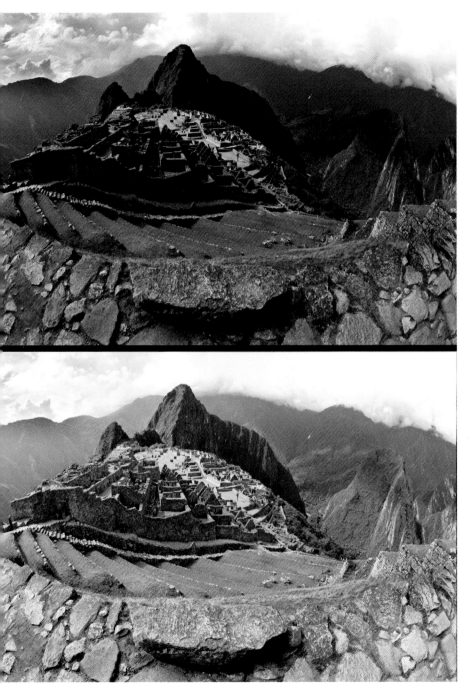

Recovery and Fill Light to the Rescue

Perhaps the two most important adjustments in ACR are *Recovery* and *Fill Light*. Recovery is great for saving an overexposed sky, and Fill Light is great for filling in blocked-up shadows.

Play with the other adjustments, and you can create an image with an expanded dynamic range, as I did here with a picture I took at Machu Picchu. The bottom image is the original.

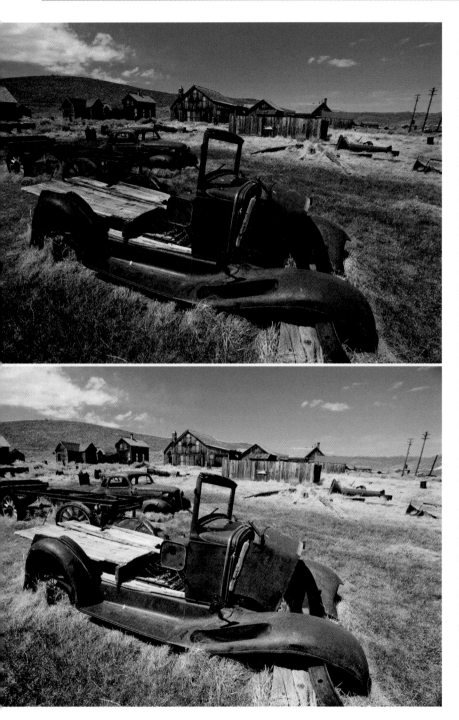

Avoid Photo Washouts

Earlier in this chapter I mention that I try to avoid overexposed areas in a scene by exposing for the highlights. The first step to achieving this is to see the light. By this, I mean to see and identify the brightest part of the scene.

In this photograph, which I took at Bodie State Historic Park in California, the boards on the back of this broken-down truck are the brightest part of the scene.

Knowing that, I set my exposure and checked the overexposure warning on my camera's LCD monitor.

Back home, I got to work with ACR.

As with some of the other images in this chapter, the contrast range was not huge in this scene. But it was big enough—from the shadows to the highlights—to require a bit of dynamic range control. The bottom image is the original.

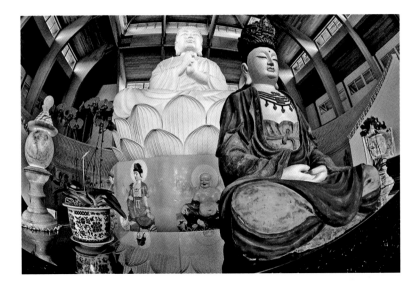

Part X

The Lucis Pro Approach

As you have seen, there are several methods for expanding the dynamic range of a single image. Here is yet another one: Lucis Pro (www.lucispro.com).

Technically speaking, Lucis® is the trade name for Differential Hysteresis Processing, a patented image-enhancement process that was originally developed to enhance detail in scanning electron-microscope images.

Practically speaking, Lucis Pro quickly, easily and accurately reveals indiscernible image information that would otherwise be difficult or impossible to view with the naked eye.

Lucis Pro is not cheap. It's about $600 compared to $80 for Photomatix. And many say it's worth it. It is a very powerful tool, and many pros I know use this Photoshop Plug-in.

In this chapter I'll give you a quick overview of Lucis Pro, which I used to create this image from a single photograph. Yet as powerful as Lucis Pro is, I still felt that the Lucis Pro image needed some tweaking. So I boosted the saturation and opened up the shadows a bit more in Photoshop, as described in a previous chapter. You'll see the straight Lucis Pro image later in this chapter.

I took this picture at the Buddhist temple near my home in Croton-on-Hudson, New York. It's one of the shooting locations for our Hudson River Photography Workshops. Participants love to shoot here, because there are so many interesting subjects.

What is most amazing to me in this image is that the windows are not overexposed and we can see into most of the shadow areas of the scene.

First Look: Lucis Pro Adjustment Window

When you open an image in Lucis Pro, you get this window. Yes! The picture is very dark. I had to make that exposure to avoid overexposing the windows in the background.

The adjustments look fairly simple. Only two sliders were used: one for Enhance Detail and one for Smooth Detail.

The basic concept is to move the Enhance Detail slider to the left to enhance the detail and to move the Smooth Detail slider to the right to smooth out the detail. If you like, you can then click the Tie Together box for automatic smoothing.

That is the quick-fix technique. I don't use this, because there is a much more effective technique that offers much more control. Check out the next page.

Split the Channels and Work in Black and White

To get the most out of Lucis Pro, you need to first check on *Split Channels*, which reveals the Red, Green and Blue channels. Then, uncheck the *Display Composite Image* box; this will give you a grayscale image. The concept is to use the adjustment sliders—for each channel—to make the best possible black-and-white image for that channel.

See this screen grab of the Red channel adjustment and apply the technique to the other channels.

After you have made your adjustments for the Red, Green and Blue channels, click *Display Composite Image* to see the result of your work.

Now you can use the *Assign Original Image Color* slider to bring back some of the color, or all of it, from your original image. You can also use the *Mix with Original Image* slider to mix your Lucis Pro image with your original.

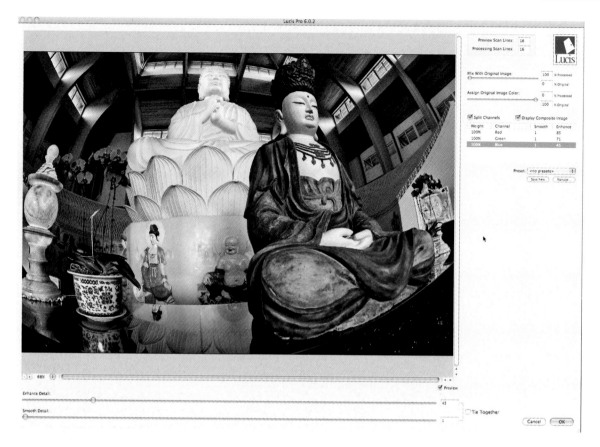

Check Before You Click

Before you check OK, go back and forth a few times to check your adjustments in each of the channels. You may be surprised at how one channel adjustment can affect your choice of the "best" adjustment of another.

Here you see my final adjustment for the Red channel. I like the image but, as I mentioned in the opening of this chapter, I felt as though the image could use a boost in saturation and a touch of Shadows/Highlights. These additional tweaks opened up the shadow areas of the scene.

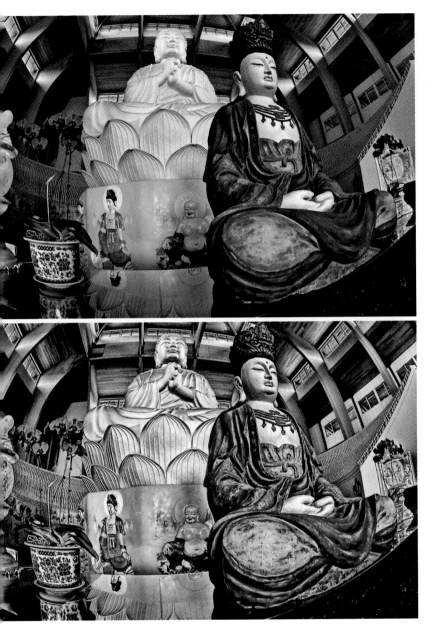

Lucis Pro Meets Lucis Art

The top image is the Lucis Pro image without any Photoshop adjustments. It is much improved over the original photograph, but it's not as vibrant as the opening image.

I created the bottom photograph using another Lucis product, Lucis Art. It won't surprise me that some of you like the original image and think this looks a bit too enhanced, while others think it looks totally cool.

Me? I think it's fun. It's kinda like Topaz Adjust on steroids.

As with all HDR effects, Lucis Art may look great on one image and not so great on another. The key is to experiment.

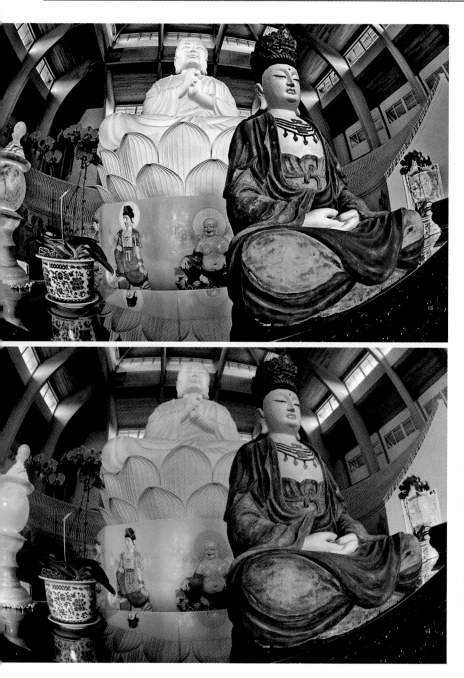

Lucis Pro vs. Photomaix Pseudo HDR

Look! Mr. Comparison Images is here again.

I think an effective method of learning is to compare images, which is why I have so many before-and-after sets of images and comparison sets in this book. Here is a pair of images that illustrates the power of Lucis Pro.

The top image is the Lucis Pro image. It has more details than the bottom image. What's more important, the highlights in the windows are not blown out in the top image; they are in the bottom image, which is the Photomatix Pseudo HDR photograph.

To sum up Lucis Pro, I'll say it's the way to go to get the most information out of a single image.

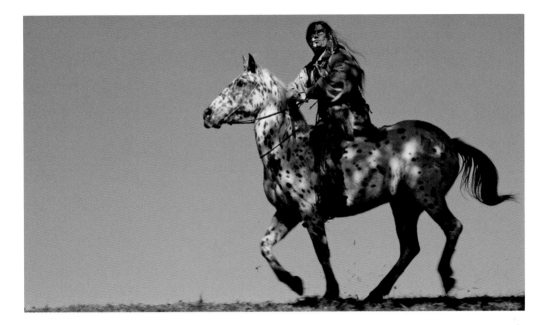

Part XI

Creating HDRs from Fast-Moving Subject Photographs

In addition to illustrating a common theme (which is *HDR photography*, in case you haven't been paying attention … haha), more than 95 percent of the pictures in this book have something in common: Nothing is moving in the scene. That's why I have included this chapter—to point out that you can expand the dynamic range of a single image in which the subject is moving … even if it's moving quite fast.

You can expand the dynamic range using the techniques you have read about in the previous chapters on Pseudo HDR, Photoshop, Lucis and Camera RAW. I suggest experimenting with all the techniques on an image, because each process gives you a different result.

Here you see the pseudo HDR image that I created in Photomatix. On page 127 is my original of this image along with the pseudo HDR image.

On the remaining pages in this chapter, I share several other examples of expanding the dynamic range of an image. Before and after examples are used.

I did not include any chitchat on those pages because I want you to see the pictures as large as possible.

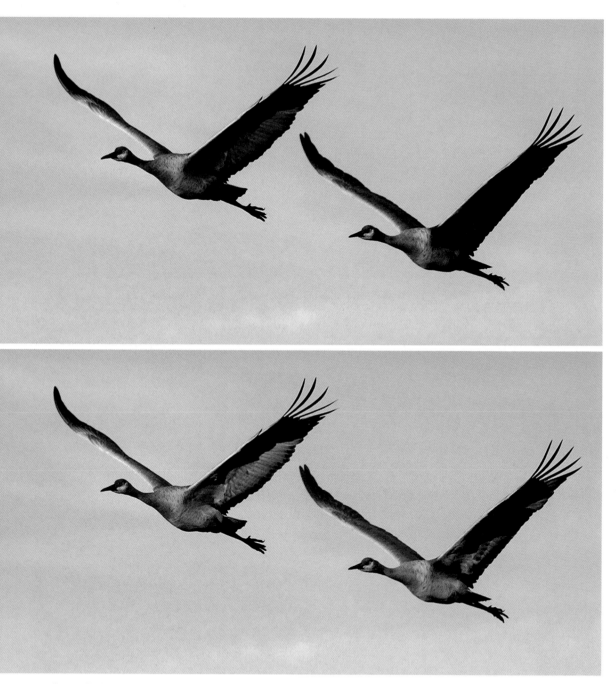

Birds in Flight at Bosque de Apache, New Mexico

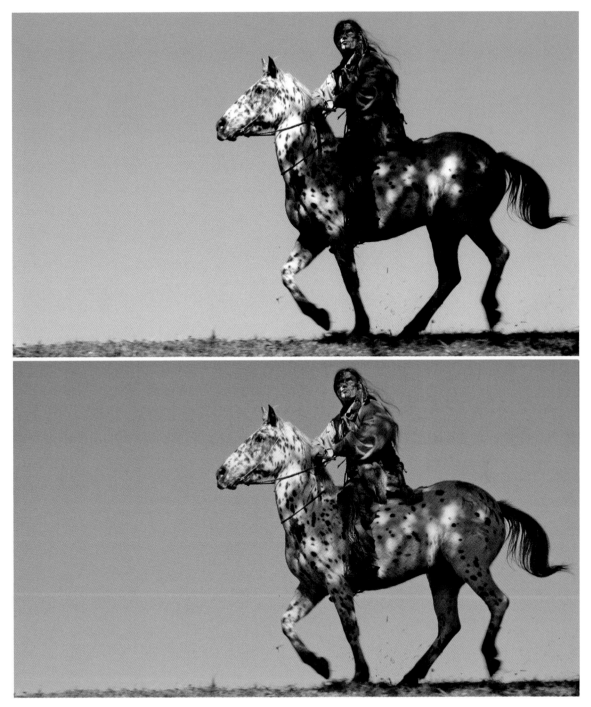

Native American Action Shot

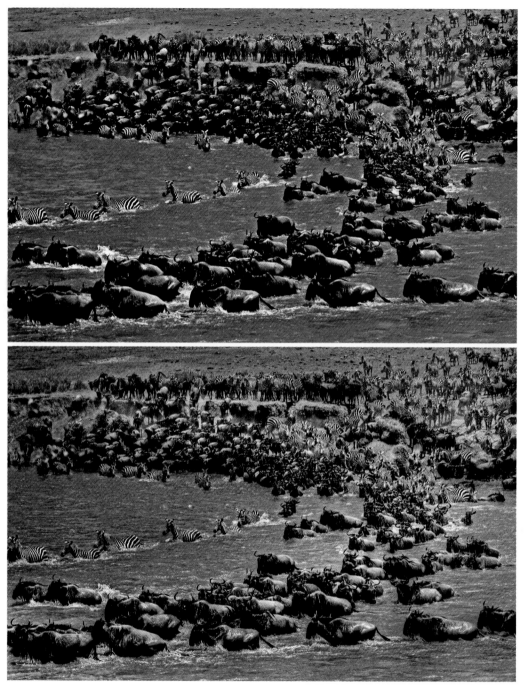

Kenya Migration

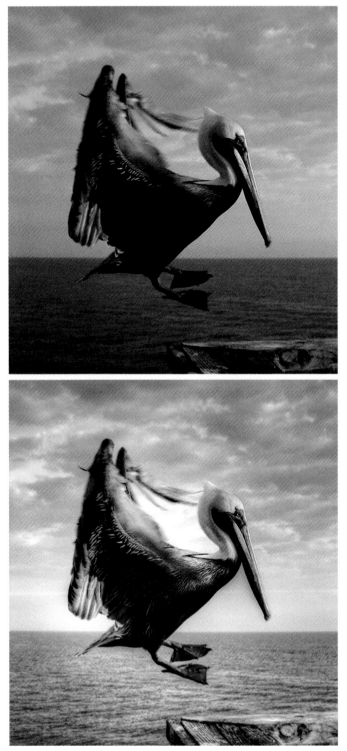

Pelican Coming in for a Landing

Lion Love Bite

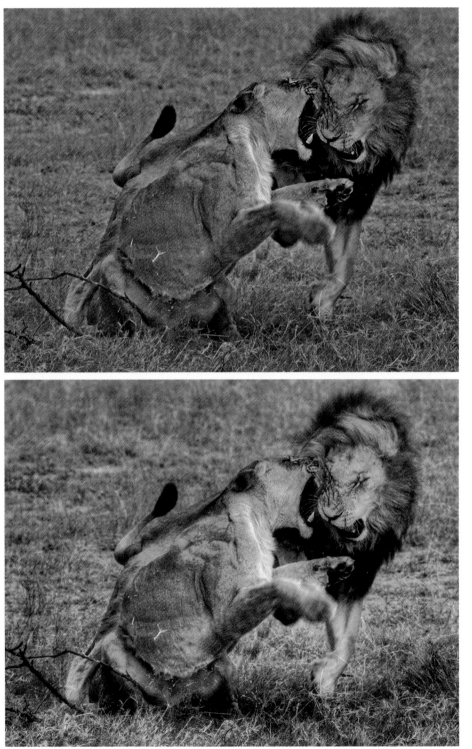

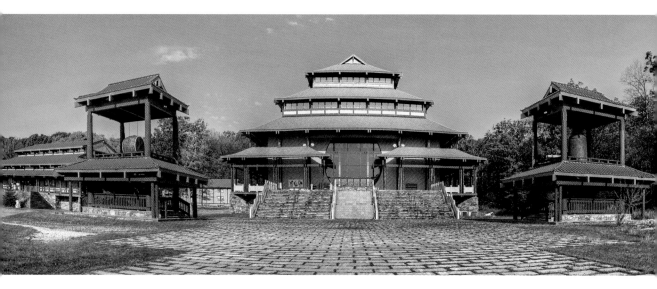

Part XII

Shooting HDR Panoramas

By now you have seen that HDR photography is a ton of fun. You can add to that fun by creating HDR panoramas from bracketed sets of images. In doing so, as you might imagine, you also add to your shooting time and processing time.

Here is one of my favorite HDR panoramas. It's an HDR image of the Buddhist temple near my home in Croton-on-Hudson, New York. It's a combination of 15 images: five sets of three bracketed images.

In this chapter I'll show you the process I used to create the panorama in Photoshop's Photomerge. I'll also share examples of HDR panoramas created from a single set of bracketed images (the way you usually create an HDR image).

Basic HDR Process Multiplied

The first step in shooting an HDR panorama is to take a set of bracketed exposures of each part of the scene.

The next step is to put those images in a folder and then select that folder in Adobe Bridge.

This screen grab of the Adobe Bridge window shows you, at the bottom of the window, each set of images outlined in red. The first set of images that I took for my temple pano is outlined in red at the top right of the window.

All of the selected images are not shown in the big window simply because they don't fit. But again, my complete set of images has been selected and is shown at the bottom of the window.

The next step is to put each set of images (three for my panorama) in a folder. Do that by choosing *Move to a Folder* or *Copy to Folder* from within Adobe Bridge.

Standard Photomatix HDR Processing

Once each set of images is in a folder, create your HDR image using the same techniques outlined in the Photomatix section of this book.

Next, put all of your Tone Mapped pictures (five in my example) in a single folder. All of my Tone Mapped images are captured in the screen grab of Adobe Bridge; my Tone Mapped folder is selected.

Let the Pano Fun Begin

From within Adobe Bridge, go to Tools > Photoshop > Photomerge. That brings up the window on the next page.

Before we get to that—because I have some room available on this page—here are some basic tips for shooting panoramas … both HDR panos and standard panos.

1) Use a tripod with a pan head.

2) Make sure the horizon line is level.

3) Set your camera on the manual exposure mode to ensure consistent exposure settings.

4) Overlap your images by at least one third.

5) Shoot vertical images … because when your pano is stitched together, you will lose some of the image area at the top and bottom of the frame.

But wait! You will see that my horizon line is not level in some of my original images. That's because I actually did not follow my own advice. When I was at the temple, I did not have a tripod … but tried a pano anyway. As you can see in the end-result, Photomerge still stitched together the pictures beautifully. However, I had to straighten the image in Photoshop using the Measure tool.

Photomerge Magic

After selecting Photomerge from Adobe Bridge, you'll get the Photomerge window.

From here, select your set of Tone Mapped images, which are already in a folder. Simply browse your computer for your Tone Mapped folder, select your files, choose Auto Layout, and click OK.

Auto Layout is the option I use for a realistic panorama. You can try the other Layout options, but I think you may prefer Auto over the others.

After you click OK, Photomerge begins to work its magic, stitching together your images. Keep in mind that the more files you have, and the larger the size of your files, the more processing time your work will require. In my experience, the processing time for each set of images usually lasts from three to five minutes.

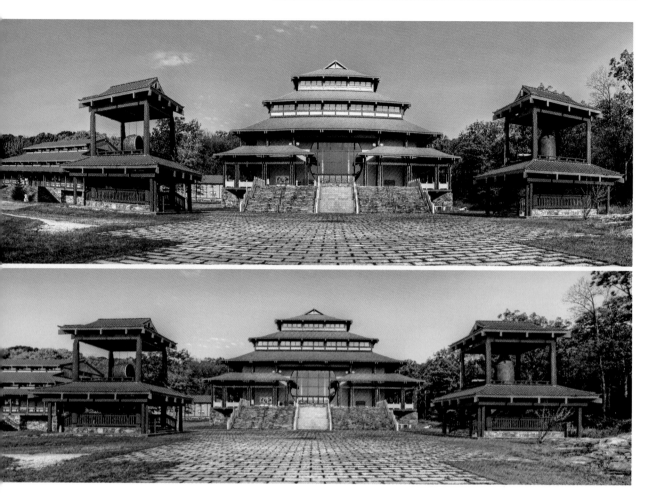

HDR Pano vs. Traditional HDR

The top image is my HDR Photomerged photograph. As you can see, the stitching is seamless. How cool is that?! All with a few clicks of a mouse!

The bottom image is an HDR created with only three images. I shot it with my Canon 17-40mm lens at the 17mm setting. I held my camera horizontally and took three bracketed exposures. I processed the images in Photomatix.

I like both images. Personally, I think the pano image is more interesting. I like the slight distortion of the foreground and the structures. It's sort of a fisheye lens effect.

In addition, I find myself looking around to see what's in the Photomerged panorama … more so than in the other image. Basically, we are looking at the scene from different angles, which is more interesting than a straight-on perspective.

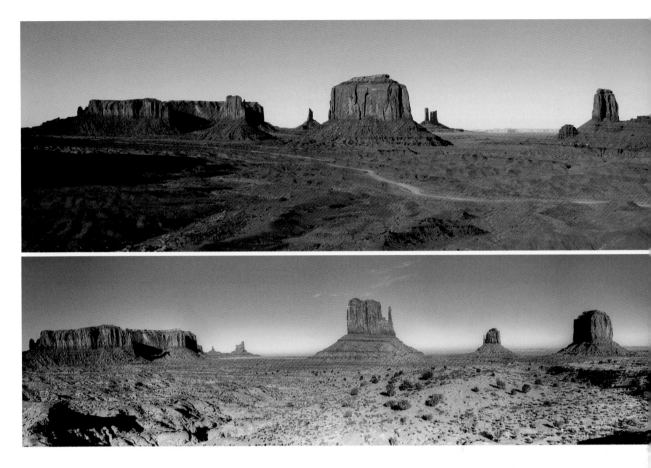

Manual Exposure vs. Automatic Exposure

Here I am in another spiritual place, this time a sacred place for the Navajo people. These are two panoramas I took in Monument Valley, which stretches across parts of Arizona and Utah.

A few pages back I suggested shooting with your camera set on the manual exposure mode. Well, these photographs illustrate why that is important.

I took the top pano with my camera set on the manual exposure mode. I took the bottom one with my camera set on the Aperture priority mode. You'll notice in the bottom image that the sky is not evenly exposed, as it is in the top image. Uneven exposure is what happens when you don't shoot on the manual exposure mode.

When determining the correct manual exposure for your pano, meter the brightest part of the scene.

You will also notice some shadows in both of these pictures. I could have reduced or eliminated them in Photomatix and Photoshop, using techniques outlined earlier in this book. However, I like the shadows in these images; they added a sense of depth to the scenes. My point: You don't always have to open up all the shadows in a scene. In fact, the more you do, the flatter a picture becomes.

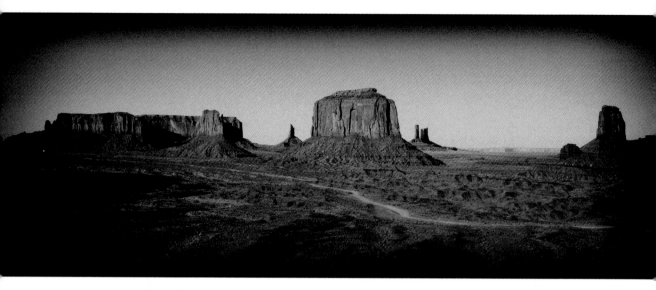

The Fun and Creativity Continue

Ansel Adams, one of the greatest landscapes photographers of all time, felt as though a picture was really never finished. He went back, again and again, to the wet darkroom to create different versions of his photographs.

I feel the same away about digital images. We can go back, again and again, to enhance and adjust them. Here is one example.

I like my Monument Valley pano. While I was on site, I felt as though I was in the Old West, in a John Wayne movie directed by John Ford. In fact, when I took this picture, I was standing at Monument Valley's John Ford point.

To enhance the feeling of the Old West in my image, I applied one of the Antique Plate filters in Nik Color Efex Pro (www.niksoftware.com), one of my favorite plug-ins.

In the following chapter are more examples of transforming a color HDR image into a black-and-white image.

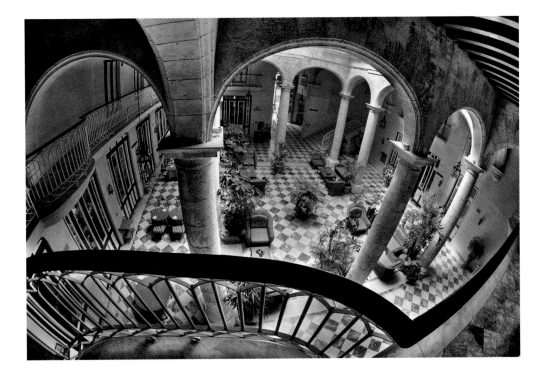

Part XIII

Converting HDRs to B&Ws

B&W HDR images are a ton of fun to create. And they expand your creative potential in the digital darkroom even further.

It's possible to create B&W HDR images in Photomatix, Photoshop, ACR and/ or Lucis Pro. I like to create the best color I can in those programs and plug-ins, and then create a B&W version of the image using Silver Efex Pro from Nik Software (www.niksoftware.com).

I use Silver Efex Pro because, like most pros, I think it offers the most creative control over tone, contrast and brightness. Here I used the Neutral effect (the default) and applied the red filter (one of several choices) to the image.

In this chapter you'll see a gallery of B&W images that are versions of some HDR color photographs you've seen in this book. The only tech-talk is on the next page, where you'll find an overview of Silver Efex Pro. I've kept chit-chat to a minimum so I could present the pictures as large as possible on each page.

Enjoy your exploration of B&W HDR. It's good fun!

Silver Efex Pro Overview

Here's a screen grab of the Silver Efex Pro window. On the left are more than 25 pre-set style options, including Neutral, Underexpose EV-1, Overexpose EV+1, High Structure, Pull Processing N-1, High Contrast Red Filter, Dark Sepia, Soft Sepia, Tin Type, Infrared Film Normal, Infrared Film Soft, Soft Skin, Wet Rocks, Dark Contrast Vignette, Antique Plate I, Antique Plate II, Holga and Pinhole.

On the right side of the window are several sliders you can use to fine-tune your image: Brightness, Contrast, Structure and Shadow/Highlight. You can add traditional filter effects and even add a control point to center the effect at a certain point in an image.

My advice: Play with all the pre-sets and sliders. A whole new world of creativity awaits you.

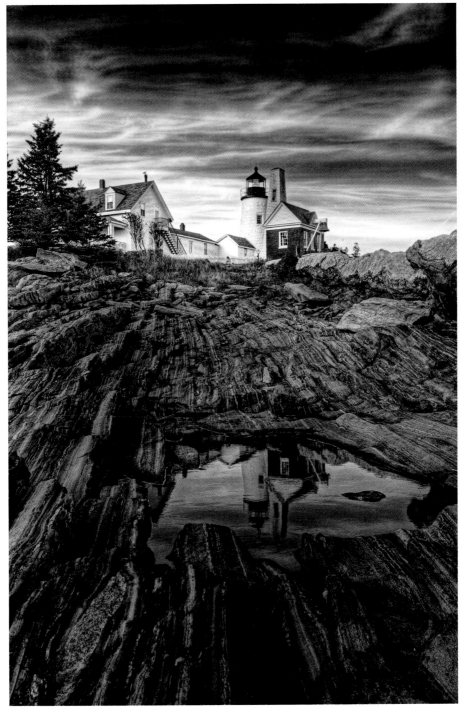

Maine Lighthouse
Nik Silver Efex Pro: Neutral

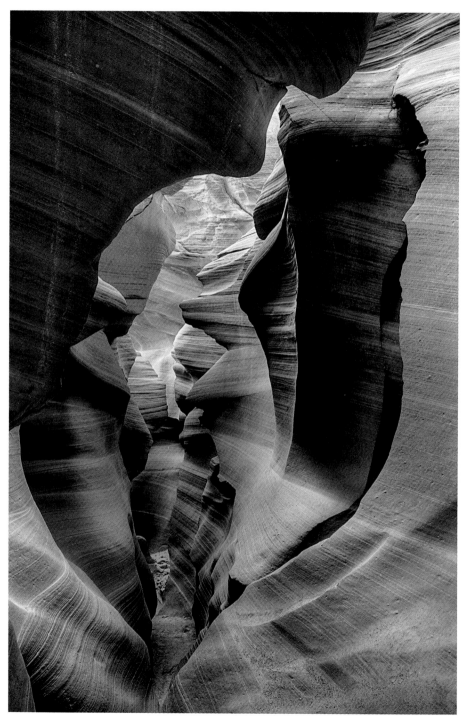

Slot Canyons
Nik Silver Efex Pro: Neutral

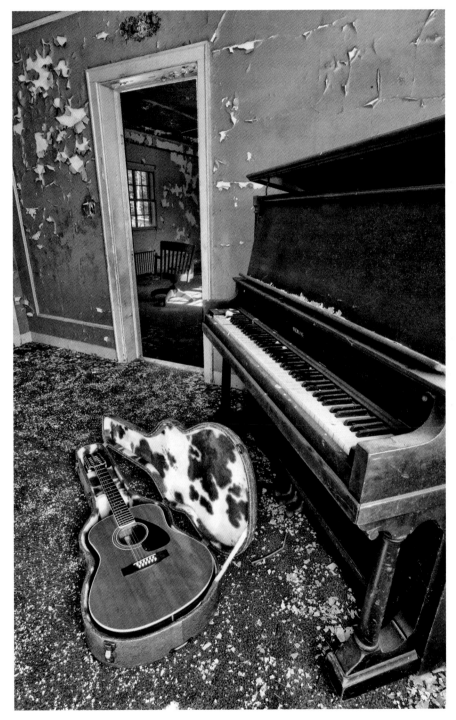

Piano Room
Nik Silver Efex Pro: Underexposed -1

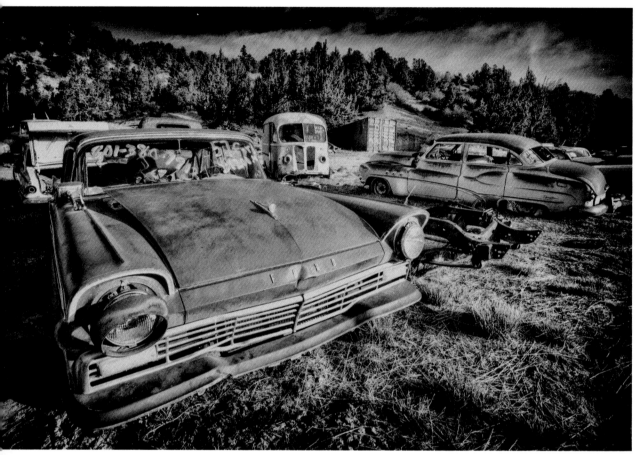

Utah Junk Yard
Nik Silver Efex Pro: Antique Plate 1

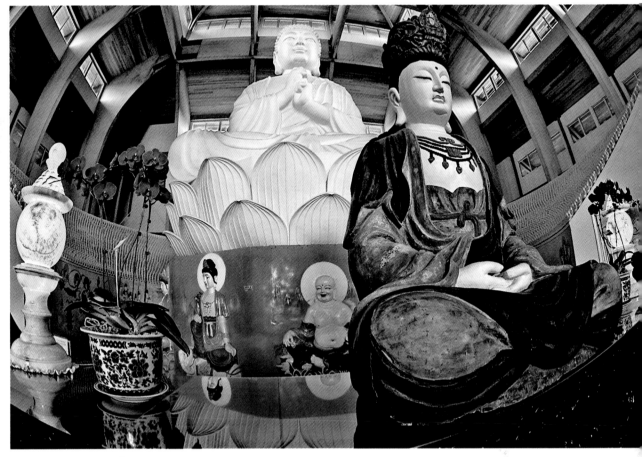

Buddhist Temple
Nik Silver Efex Pro: Neutral

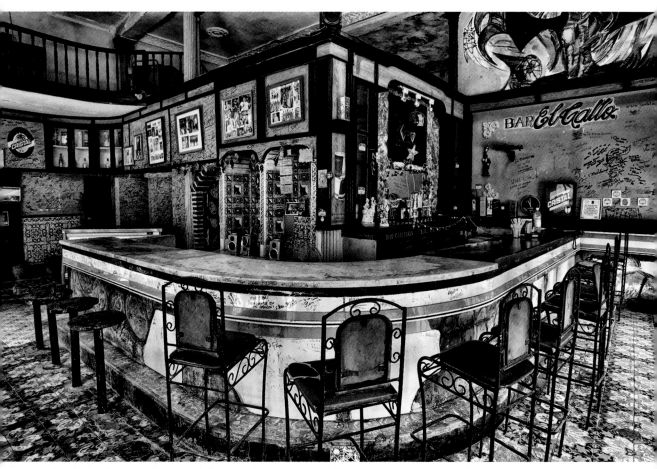

Old Havana Bar
Nik Silver Efex Neutral

If you'd like to get into B&W imaging using Silver Efex Pro, enjoy a 15% discount on the plug-in on the Nik Software site by using this code upon checkout: Rsammon.

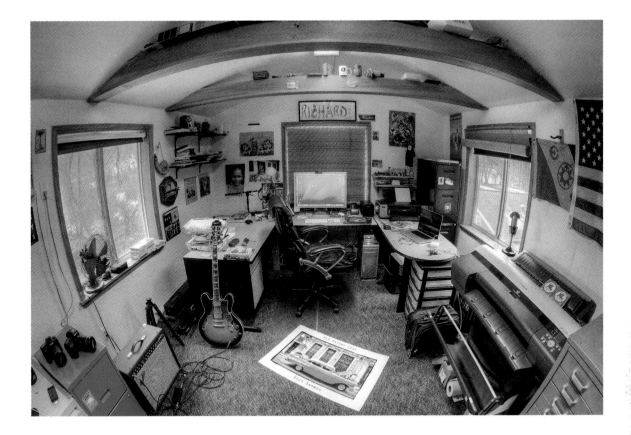

Part XIV

My HDR Gear: The Stuff of Magical Imagery

This is an HDR, fish-eye view of my workspace, where I use Photomatix, Topaz Adjust and Photoshop to create my HDR images. When I work, I pull down the shades so that the room light is constant, allowing me to take full advantage of my Apple 30-inch Cinema Display, calibrated with ColorMunki.

My Apple Quad-Core has 12GB of Ram and 500GB of hard drive space. For backup, I have one internal hard drive (Time Machine) and two accessory hard drives: G-Tech. For added backup and security, I have a Drobo (with four Seagate 1.5 GB hard drives) on my desktop.

I use a Wacom Intuos 3 table for precise control over image enhancement.

My photo printers: Canon Pro 9000 Mark II and Canon IPF 6100.

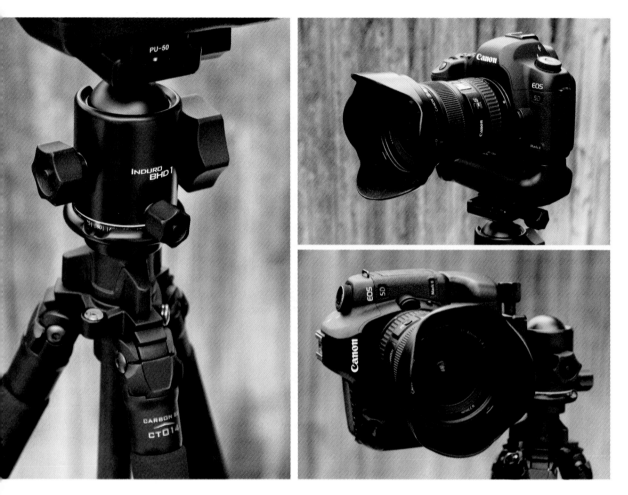

Cameras, Lenses and Tripods

For most of the pictures in this book, I used my Canon 5D Mark II and set the image quality to RAW. More than 90 percent of the images were taken with my Canon 17-40mm lens. The others were taken with my 24-105mm IS zoom and my Canon 15mm full-frame fisheye lens.

I used Induro tripods and ball heads; my CT 014 and BHD 1 are shown here. I like the tripods because they are rock steady. Plus, the ball heads feature a level and offer quick rotation for vertical and horizontal shooting.

The ball heads also features a quick-release mount, so I can quickly switch cameras or break down my gear in a flash.

In-the-Field Gear

When I am on location, I travel with my Mac Book Pro, G-Tech 250 portable hard drive, Lexar card reader, and plenty of Lexar memory. My card reader gets plugged into my portable hard drive, which is plugged into my laptop. This setup allows me to download my cards to my laptop and portable hard drive at the same time.

The downloading process begins with all the cards face up on a table. After a card is downloaded, I turn it face down …. which helps prevent a card mix up. I only format a card after the pictures from it are on my laptop and portable hard drive.

HDR Rocks!

Throughout this book, I share examples of the pictures I took to create a single HDR image. Well, here is the final example. I took these four shots of my studio to create the opening image for this section.

Thanks for visiting my studio and my world of HDR imaging.

Good luck on your HDR explorations. Please keep in touch on www.ricksammon.com.

Part XV

Cool Web Sites

I hope you learned a lot from reading this book, and I hope you had a lot of fun. But the HDR learning and fun does not have to stop here.

This chapter features some cool web sites for additional HDR—and general photography—learning.

While reading this chapter, keep in mind that you can get discounts on some HDR programs and plug-ins at the Plug-In Experience: www.pluginexperience.com.

On this page is a screen grab of the Topaz Labs web site. Topaz makes more than Topaz Adjust, as you see. Read about the cool plug-ins, because they can expand your photographic vision, too.

www.pluginexperience.com

www.hdrsoft.com

www.unifiedcolor.com

True HDR Plug-in Sites

Photomatix and HDR PhotoStudio are true HDR programs. I have not used HDR PhotoStudio (because it was not available at the time of this writing), but I have since heard good things about it.

As you know, I have used Photomatix, and I love it!

www.oneonesoftware.com

www.niksoftware.com

Favorite Plug-in Sites

No, onOne software and Nik Software don't offer HDR plug-ins (at the time of this writing, anyway). However, they do offer cool plug-ins that let you expand your HDR and non-HDR imaging techniques.

My Web Site

Hey, I hope you can stop by my web site, www.ricksammon.com. You'll find lots of articles and links on the site as well as a listing of my HDR and traditional photography workshops.

www.ricksammon.com

Writing captions for our photographs is good way for us to realize what we were trying to say with an image (and how we were feeling) when we took the shot. Try it . . . you'll find it an interesting exercise.

My caption for this image: Lost is Space.

http://rickrawrulessammon.blogspot.com.

Rick's Digital Learning Center

I post how-to information almost daily on my blog, Rick's Digital Photography Learning Center: http://rickrawrulessammon.blogspot.com.

What's cool about the blog is that you can ask me questions and get almost instant feedback, if I am in town.

Please stop by and say, "Hi."

www.dpexperience.com

Digital Photo Experience

The Digital Photo Experience is all about you. I started this web site with Juan Pons and we are having a blast. We post two new articles each weekday. We also have a bi-monthly podcast.

See www.dpexperience.com for info. If you have a question for the podcast, you can write me at rick@dpexperience.com.

Home | Jump In | A-M Art | N-Z Art | How-to | Plug-ins | Photo

PLUG-IN EXPERIENCE 2/10

Where You Awaken the Artist Within With Plug-ins

Benjamin Todd: Artist of the Month

www.pluginexperience.com

Plug-In Experience

Here is a look at the home page of my Plug-In Experience web site: www.pluginexperience.com. Lots of learning here, too!

Better yet, if you send me an image, you might be an artist of the month!

You'll find info on how to submit an image on the site.

Stuck in Customs

My pal Trey Ratcliff started this totally awesome web site, Stuck in Customs: www.stuckincustoms.com.

Trey posts a new picture with an HDR tip almost daily. And, he wrote a cool HDR book, too: *Stuck in Customs, a World in HDR.*

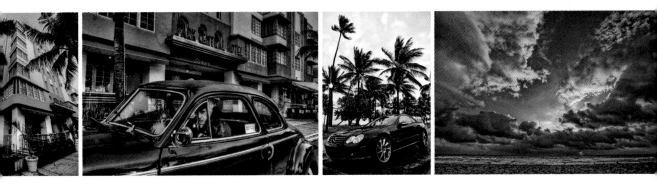

Post Script

Learn by Questioning

Up until now, I have offered suggestions on how to create true and pseudo HDR images. In fact, I've shared everything I know about HDR photography ... and some of what I know about photography in general.

Now, I'd like to turn it over to you. I want to use a teaching technique that I learned when I first started taking pictures. The technique: Look at a picture and try to figure out how it was created. It's actually a great way to learn. What's more, beyond this page, there is no text on the pages to distract you.

Look at the following 18 pictures. I took all of them in Miami's South Beach and at the magical Magic Beach Motel in St. Augustine, Florida. Question each picture. Ask yourself: Is it a true or pseudo HDR image? Was Topaz Adjust added? Was a plug-in effect added? What Photoshop adjustments—selective or global—might have been used? How many exposures might have been taken? What lens was used? How was a sense of depth created? Did the time of day or indoor lighting conditions affect the image? How was the vivid or subtle color achieved?

As the saying goes, "Ask and you shall receive." In this case, you'll receive additional insight to how your own HDR images can be created.

The first 13 pictures were taken in South Beach. The last five were taken at the Magic Beach Motel.

As with the Preface to this book, I will end this Post Script with the original files that I used to create this images.

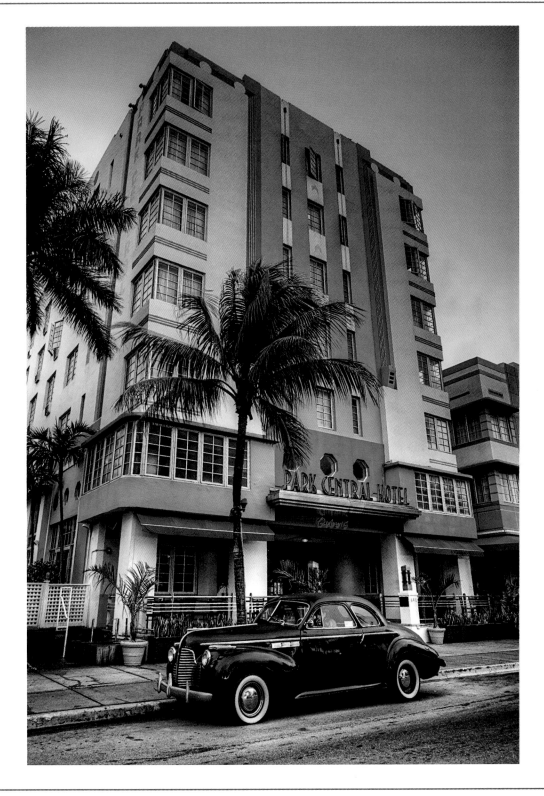

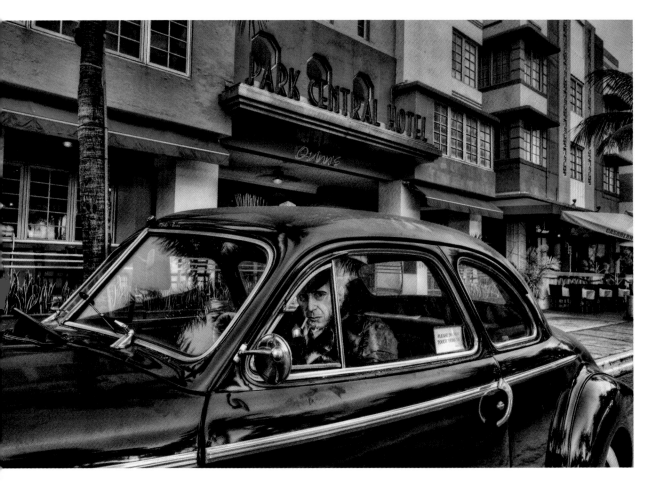

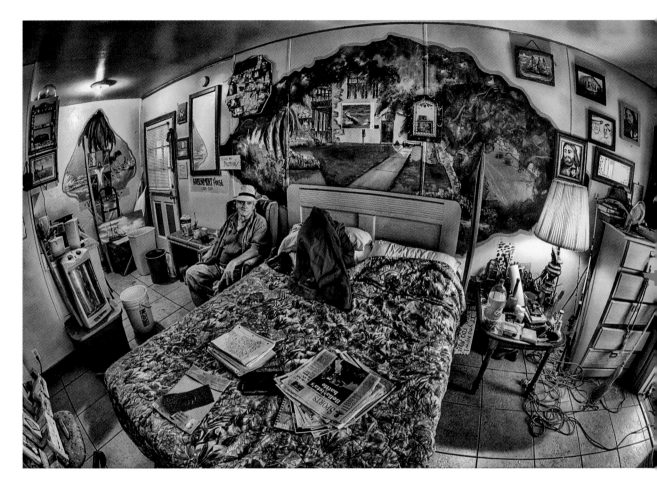

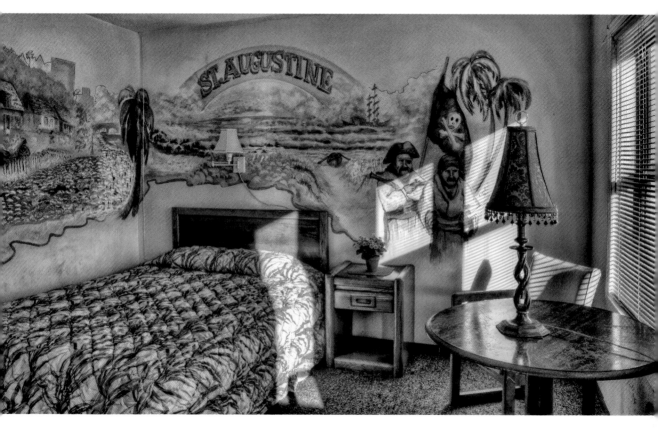

More Before HDR Images

For those of you who are curious about the "before" pictures that I used to create the pictures in the Post Script, I thought I'd share the middle/average exposures.

The scene on the opposite page on the bottom right had the most contrast and therefore required the most HDR work. On the last page of this Post Script are the before/after images together … so you can see, once again, the magic of HDR images.

Picture Processing Info

Okay, for those of you want to know the processing info behind all the pictures in this Post Script, all you have to do is check my blog: http://rickrawrulessammon.blogspot.com. In the Search Window, type in HDR Secrets/Post Script Processing Info.

Don't peak! Again, you can learn a lot by looking.

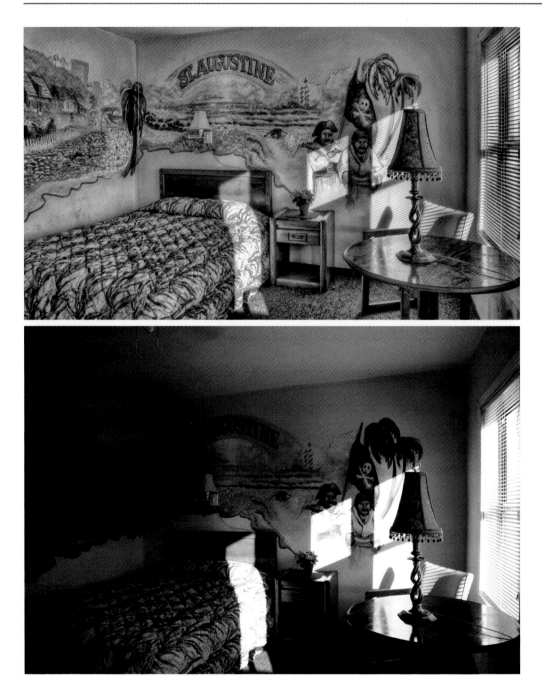

Look Ma! No Details Lost

This scene had the widest contrast range of any shot in this Post Script. Here you see how Photomatix and Topaz Adjust worked their magic ... perhaps not coincidently at the Magic Beach Motel!

Index